HIDDEN
HISTORY
of
ST. JOSEPH
COUNTY,
MICHIGAN

HIDDEN HISTORY

of

ST. JOSEPH COUNTY, MICHIGAN

Kelly Pucci

THE
History
PRESS

Published by The History Press
Charleston, SC
www.historypress.net

Copyright © 2017 by Kelly Pucci
All rights reserved

First published 2017

Manufactured in the United States

ISBN 9781467118224

Library of Congress Control Number: 2016939310

CONTENTS

ACKNOWLEDGEMENTS

I owe a huge debt of gratitude to the following:

President Martha Starmann, the board and members of St. Joseph County Historical Society for the wondrous array of documents and artifacts related to the history of St. Joseph County, carefully and lovingly displayed in the U.S. Land Office in White Pigeon and in the Historic Archives.

Kathy Brundige, St. Joseph County One-Room Schoolhouse archivist.

Holly Stephenson, St. Joseph County Historical Society curator.

Thomas Talbot, local historian, always ready to lend a hand.

The librarians of St. Joseph County, especially those at the Colon Township Library, the Burr Oak Township Library, the Three Rivers Public Library, the Sturgis District Library and the Nottawa Township Library.

Members of the Colon Historical Society.

The people of St. Joseph County, who are mindful of a rich heritage worth preserving.

Introduction

St. Joseph County was established in 1829. It was named for the St. Joseph River (formerly the River of the Miamis) that passes through the county, which in turn was named for St. Joseph, the patron saint of France. Originally, there were only five townships: Brady, Flowerfield, Green, Sherman and White Pigeon. Today, there are sixteen townships: Burr Oak, Colon, Constantine, Fabius, Fawn River, Florence, Flowerfield, Leonidas, Lockport, Mendon, Mottville, Nottawa, Park, Sherman, Sturgis and White Pigeon.

This is a brief history of these sixteen townships—a quirky, unusual and hidden history of the people of St. Joseph County. But long before Michigan officially created St. Joseph County, there was the land and the people who lived on the land. Here is their story by local historian Thomas Talbot.

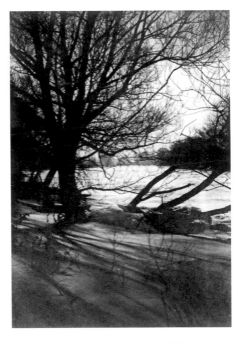

The St. Joseph River runs through St. Joseph County. *Courtesy of the St. Joseph County Historical Society.*

TABLE of DISTANCES

FROM \ TO	CENTREVILLE	THREE RIVERS	CONSTANTINE	MOTTVILLE	WHITE PIGEON	STURGIS	FAWN RIVER	FREEDOM	BURR OAK	COLON	LEONIDAS	FACTORYVILLE	MENDON	PARKVILLE	FLOWERFIELD
CENTREVILLE															
THREE RIVERS	7														
CONSTANTINE	10¾	9													
MOTTVILLE	15	14½	5½												
WHITE PIGEON	11¼	11¼	4	5¾											
STURGIS	12	19	15½	17½	11½										
FAWN RIVER	17¼	24½	20¾	22½	16¾	5½									
FREEDOM	16¼	23¼	19¾	21½	15¾	4¼	1¾								
BURR OAK	14¾	21¼	20½	25¼	19	8	5	3½							
COLON	11½	16½	21¼	20¾	22¾	14	14	12½	9						
LEONIDAS	12½	17½	22½	27¼	23¾	17	19	17½	15	6					
FACTORYVILLE	15¾	21¾	25½	30¾	27	20½	22¼	20½	17	7½	3½				
MENDON	8	12¼	17¾	23	19¼	16½	20¼	18½	17	8¾	5¾	9			
PARKVILLE	7¾	8¾	17¼	22½	18¼	19½	24½	23½	21½	14¾	12	15¼	6		
FLOWERFIELD	15¾	8¾	17½	23½	20	27¾	33	32	30½	24	20½	23½	15¼	8½	

The above distances were measured on the NEAREST OPEN Public ROADS.

Distances between villages and cities in St. Joseph County.
Courtesy of the St. Joseph County Historical Society.

ANCIENT MAN IN ST. JOSEPH COUNTY, MICHIGAN

By Thomas Talbot

To better understand the ancient cultures that existed here in the river valley throughout the ages, we must first recognize the drastic changes in the climate and environment. It is by the adaptations to these changes that we see distinct cultures emerge and fade.

The last ice age started about 110,000 years ago and ended roughly 14,000 years ago. Its coldest point was around 17,000 to 21,000 years ago. The glacier called the Laurentide Ice Sheet pushed its way down through our region, extending well into Illinois, Indiana and Ohio. It acted like a giant bulldozer in the sense that it removed all the trees and topsoil, pushing forward and covering it all up with several feet of crushed rock and gravel. By 14,000 years ago, it was well into the process of melting and receding.

Various types of grass started to appear in the bare dirt left by the melting ice, and soon this region was covered with vast expanses of rich grasslands. Conifers—small, shrub-like evergreens—would next appear and dot the landscape. The evergreens eventually gave way to the hardwoods. The hardwood forests of Lower Michigan would cover the entire region, yielding only to the lakes, rivers, marshes and prairies.

Ancient man was here fourteen thousand years ago as the ice age was coming to an end, and after thousands of years of changing environment, he was here just a few hundred years ago to greet the first European explorers. He left stone tools scattered around his ancient village sites. Tools of different shapes and sizes. Tools of varying colors and hardness.

The method in which a tool was attached to a handle or a shaft is referred to as the hafting method. Each culture had its own distinct hafting method because each manufactured tools for its particular hunting and dietary needs. So the point to be made is this: we had distinct changes in the climate, which meant distinct changes in the plants and animals that adapted to these new environments, which meant distinct changes in ancient man's diet, which meant distinct changes in the manner in which he

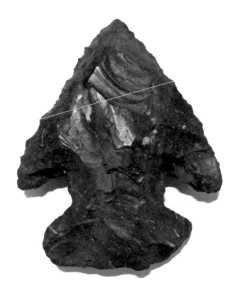

An early Archaic artifact. *Courtesy of local historian Thomas Talbot.*

A late Archaic artifact. *Courtesy of local historian Thomas Talbot.*

11

ade his tools. This is how we can tell the age of some of the artifacts found
ere in the county—by the shape of the base of the tool and the particular
afting method.

The ancient cultures can be broken down into ten basic groups with
approximate dates of their existence: Paleolithic Culture, 12,000 to
14,000 years ago; Transitional Paleo Period, 11,000 years ago; Early
Archaic Period, 9,500 years ago; Archaic Culture, 8,500 years ago;
Middle Archaic Period, 7,000 years ago; Late Archaic Period, 5,000 years
ago; Laurentian Period, 4,000 years ago; Adena Culture, 2,500 years ago;
Hopewell Culture, 1,500 years ago; and Woodland Period, 1,200 years ago.
This takes us up to the Historic Period and the time of European influence.
This is when the Stone Age in St. Joseph County came to an end.

The Paleolithic Culture

The Paleo, or Clovis, people lived in St. Joseph County fourteen thousand
years ago but were not permanent residents. They would follow the large
herds of herbivores that would migrate up from the south every year to feed
on the grasslands. Herds of bison, mastodon and wooly mammoth would
make their way north on well-established trails, feed all summer and then,
when the first winds of autumn would start to blow, turn and head south
again, ever shadowed by the Clovis people, who lived their lives completely
nomadically. They are called the Clovis people because of the finely crafted
Clovis, or fluted spear points, they used. The term "fluted point" refers to a
thinning flake that was struck from the base of the point, up the center on
both sides, making it thinner in the middle. This was part of their distinct
hafting method. Because the Paleo people had no permanent villages, Clovis
points are a rare find here in our county.

Transitional Paleo Culture

This culture came into existence around eleven thousand years ago. Called
the Transitional Paleo Culture, they were just that—a whole culture of
people in transition. The mastodon and the wooly mammoth were extinct,
and with them went an entire way of life for ancient man that had existed for
thousands of years. So they roamed the region, hunting what they could and
adapting to a warming climate and a changing environment. Their projectile

points were very similar to the Clovis points in shape but without the fluting flake being removed. There was no longer a need for that finely crafted hunting spear of the Clovis people. Again, because they had no permanent villages, Transitional Paleo points are found scattered around the county.

THE ARCHAIC CULTURES

The four Archaic cultures will fast-forward us nearly five thousand years. This time period represents some of the biggest changes in climate, environment and tool manufacturing.

The Early Archaic people saw the highest temperatures and lowest Great Lakes water levels of the ages. The hardwood forests started to appear during these times, and the bow and arrow would prove to be much more efficient than the spear for hunting in this environment. The use of pottery came about around the Middle Archaic Period and continued throughout the ages. Woodworking tools such as stone chisels, gouges, adzes, celts and axes would appear during these times, along with crude agricultural tools. It was during the Archaic Period that ancient man took up permanent residence in St. Joseph County, living year round in one of the most fertile river valleys east of the Mississippi.

A Land of Plenty

One of the things our county is noted for is the abundance of rich, sandy loam soil. Gentle rises of this well-drained fertile ground, bordering lakes or rivers, were excellent places for ancient man to make his camps. By the time the Laurentian Period came about, roughly four thousand years ago, the indigenous people were living on these well-established village sites, some of which had been occupied on and off for thousands of years.

Deer and small game were hunted for their meat and skins. Fish were abundant and could be trapped or netted. The forest was rich with nuts, roots and berries, as well as medicinal plants. The people of the Adena Culture were known to supplement this diet with garden-grown gourds, seeds and grains. The Hopewell people were saving the biggest seeds from the healthiest and most productive plants to sow the following year, thus creating some of the first hybrid plants.

The people of the Woodland Culture harvested wild rice from the little pothole ponds and spring heads found on and around the prairies. Sugar camps were established near maple groves. In the late winter, maple sap was boiled down into sugar using heated stones. These camps can be identified today by the large amounts of burnt and heat-fractured rock that litter the area. This section of the St. Joseph River Valley was so bountiful that any resources it lacked could be easily bartered for.

Chert Use

Chert is the material used to chip out arrowheads, spear points and stone knives. It is often referred to as flint but is actually varying grades of chert. Although southwestern Cass County was a source for some chert, with a small outcropping here in our county near Constantine, the main source for this material was through travel and trade. With the St. Joseph River, an avenue for ancient commerce, winding through the middle of the county, chert from all over the tri-state area made its way here. Bayport chert from the thumb area here in Michigan was used in the river valley along with Norwood chert found near Charlevoix. Attica chert from west-central Indiana and hornstone from the southern part of the state, near the Ohio River, were used extensively as well. Stone from the Flint Ridges in Ohio was heavily traded into our river valley. These are only some of the major chert sources used by ancient man in our county. Rough and unfinished tools called preforms or quarry blanks were manufactured at these outcroppings and traded throughout the region.

The End of an Era

The first European explorers brought with them many materials that were completely foreign to the indigenous people here in the river valley. Bottle glass could be chipped like chert. Some arrow points and hide scrapers made from this material have been found in the county. Metal from discarded copper pots and kettles was used to make jewelry such as necklaces and breastplates, as well as tools like picks, awls, arrow points and knives. As these early explorers started to settle in the river valley, building forts and trading posts, a lot of their goods were stored in kegs—flour, gunpowder, nails, wine, et cetera. As these kegs were discarded, the band iron that held them

together was salvaged by the natives and used for tool manufacturing. Soon, band iron tipped their arrows, knives and lances. Stone chisels, gouges, axes and adzes were replaced with iron tools. Iron quickly became a trade item and, along with other materials, brought fourteen thousand years of stone use to an abrupt end.

By the 1830s, the white settlers were coming here from the east and claiming land for themselves. The native people were forced to live on ever-shrinking reservations and eventually were moved west. Some of them came back and settled near Athens, Michigan, on the Pine Creek Reservation, where their descendants still live today.

BURR OAK TOWNSHIP

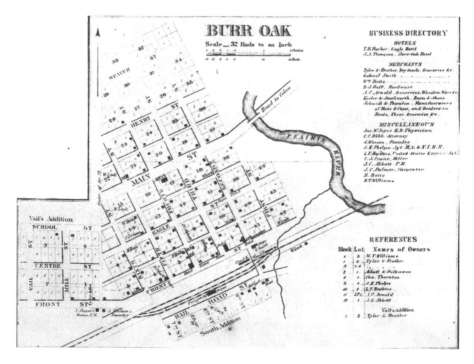

Burr Oak Township. *Courtesy of the St. Joseph County Historical Society.*

The Case of the Missing Toolbox

Some disputes reach resolution quickly, without much notice from disinterested parties. Others, though seemingly simple and unimportant, live on through the ages, the integrity of those involved questioned and the merits of the dispute examined by legal scholars on both sides of the Atlantic.

Such is the case of Burr Oak's missing toolbox.

This is what happened. In April 1866, a resident of Burr Oak asked his friend Loring Culver to ship a box of tools to the Burr Oak railroad depot. A few days later, Mr. Culver sent a receipt of the transaction to his Burr Oak friend Noah Root. The following day, Mr. Root went to the railroad depot, but no toolbox had arrived. He returned the next day. Still no toolbox. He continued this for several days.

Finally, he hired Quincy VanVoorhis, a lawyer who sued the Great Western Railroad Company on his behalf, claiming that the railroad "has failed and neglected to deliver said goods to the plaintiff at any place, and has converted them to defendant's own use, or lost, or mislaid the same, so that said goods are lost to the plaintiff" and "that the plaintiff (Noah Root) has suffered great damage in consequence of the failure of the defendant to deliver said goods, in loss of time and in his business....Wherefore the plaintiff demands judgment against the defendant for Two Hundred Dollars [the value of the tools, $150, plus $50 for lost wages]."

At trial, the court considered as evidence a document signed by railroad agent W.C. Hurley verifying that he received the box of tools from Loring Culver. The court decided in favor of Mr. Root and awarded him $208.08.

The railroad requested a new trial. Undeterred, Quincy VanVoorhis filed a motion demanding that the railroad pay the original award of $208.08 and "for his costs and disbursements, amounting in the whole to the sum of Eight Hundred and Eighty-six Dollars and Sixty-three cents."

The railroad paid Mr. Root nothing and counterattacked with its own motion to reverse the court's decision to deny a new trial.

The case dragged through the legal system for years, and while the matter of what happened to the box of tools is of little interest to anybody but Noah Root, the complexity of issues cited by the lawyers and comments by judges—including a lengthy opinion longing for simpler modes of transportation before railroads made the Erie Canal obsolete—caught the attention of Isaac F. Redfield, who wrote about *Root v. the Great Western Railroad Company* in his treatise on American railroad law. In England, lawyers cited

the Burr Oak case in a dispute involving transportation of livestock on the British railway system (see *Hall v. North Eastern Railway Co.*, Law Reports, 10 Queen's Bench, 437).

THE NEWTON GANG

Willis Newton boasted that he and his brothers stole more money than Jesse James, the Dalton Gang and Butch Cassidy's Wild Bunch combined, robbing over eighty banks and six trains, including the largest train robbery in U.S. history.

Armed with pistols, shotguns and explosives, the gang terrorized citizens in small towns from Texas to Canada, but they were no match for Miss Lury Bushnell of Burr Oak, Michigan.

The sixty-seven-year-old Miss Bushnell worked the overnight shift at the Southern Michigan Telephone Company, which shared office space with the First National Bank in Burr Oak. Early one morning in October 1919, she heard a noise outside. Looking through an open window, she saw an unfamiliar man. The stranger threatened to kill her if she didn't follow his directions. Unfazed, Miss Bushnell shut the window, pulled down the shade and went to work jamming phone plugs into the old switchboard. Confused, the robber shouted to her that the gang had cut the telephone wires, and he repeated his threat to kill her.

Miss Bushnell rebuked the robber for thinking that she was alone, which she was, and warned that soon "the whole town will be here." With that, the frustrated robber pried opened the window, but the brave Miss Bushnell beat him with a stick as he climbed through the window. Ignoring his order to keep still, she shouted, "I never kept still in my life, and I'm not going to begin now!" She screamed as loud as she could and for good measure instructed a second robber, who pointed a gun at her face, to step back because he was "altogether too close."

Miss Bushnell's screams awoke clothing merchant A.A. Bonner, who fired his shotgun at the gang now assembled outside. He didn't hit anybody, but one of the robbers inadvertently shot a colleague, piercing his lung.

The Newton Gang quickly left town without their injured comrade, who died three weeks later, without any cash from the First National Bank and without dampening the spirits of Miss Lury Bushnell, loyal employee of the Southern Michigan Telephone Company.

Mr. Lock's Train Station

Burr Oak seems to be a popular name for places located near burr oak trees, and Burr Oak, Michigan, is no exception.

There's Laura Ingalls Wilder's girlhood home in Burr Oak, Iowa, and Burr Oak State Park on Burr Oak Lodge Road in Glouster, Ohio. For a time, Burr, Nebraska (Otoe County), was called Burr Oak, but the name was changed to avoid confusion with Burr Oak, Nebraska (Douglas County).

Kansas has two Burr Oak townships, one in Jewell County and another in Doniphan County. It's odd that the two Kansas counties did not follow suit to avoid confusion.

Then, of course, there's Burr Oak in St. Joseph County, the village identified for local burr oak trees, but for a few years it was named Lock's Station. In 1851, landowners Henry Weaver and William Lock platted the village of Burr Oak. But in 1852, Mr. Lock donated a chunk of land for a train station with one condition: villagers would have to rename the village Lock's Station. They did, but five years later, they had a change of heart. Lock's Station once again became Burr Oak, Michigan.

The Man Who Had More Stuffed Stuff than Everyone Else

While working as an embalmer in Burr Oak, Mr. Elliott H. Crane—or Professor Crane, the title he bestowed on himself—uncovered important evidence that mound builders lived in St. Joseph. When he excavated the Colon Mountain, he found tools he attributed to mound builders: a fireplace and the remains of six fortifications. An amazing find for a multitalented amateur.

His sworn testimony in *Allen v. Crane*, a property dispute of little significance, gives us a peek at Professor Crane, the man who explored the highest point in St. Joseph County.

Burr Oak resident Elliott H. Crane described himself before the Michigan Supreme Court as follows:

> *I am an embalmer and taxidermist. I am a naturalist. I am an archaeologist, a collector of curios, a dealer in curios now and then, here and there, an exporter, and I am an explorer of mound, and I do a little lecturing once in a while.*

I have collected minerals and geological specimens of every kind, and things of mineralogy all that you can think of, and I have got some birds. I have got embalmed specimens and birds that I have skinned and stuffed, and others that were recently mounted in both ways. I have got more stuffed than anything else.

When he lived in Burr Oak, Professor Crane practiced embalming techniques with concoctions he made himself. On September 1, 1868, he was granted a patent for an "Improved Compound for Embalming Dead Bodies," later known as "Elliott H. Crane's Electro-Dynamic Mummifying Compounder," which he sold to amateur taxidermists throughout Michigan, whose numbers were greater than Michigan's embalmers. An old calling card adorned with a photo of local birds stated that Crane's mummifying compounder could "preserve birds, animals and reptiles without removing the flesh…thus saving 75 percent of the time formerly occupied in skinning and stuffing." Perhaps as an afterthought, Crane added to the card: "Human Bodies are also perfectly Embalmed by this process."

His patent application conveys his enthusiasm for the compound: "This wonderful compound may be applied to the throat, mouth, and cavity from which the intestines have been removed in dry power, thereby embalming and mummifying the flesh." To make life easier for taxidermists in search of dead animals, Elliott Crane patented an improved animal trap.

Elliott H. Crane's collection of less lethal patented inventions includes a doorbell burglar alarm combo, an improved fish hook and a multi-section fishing rod. Upon his death, E.H. Crane donated his collection of artifacts to the Kent Scientific Museum in Grand Rapids, now the Grand Rapids Public Museum.

COLON TOWNSHIP

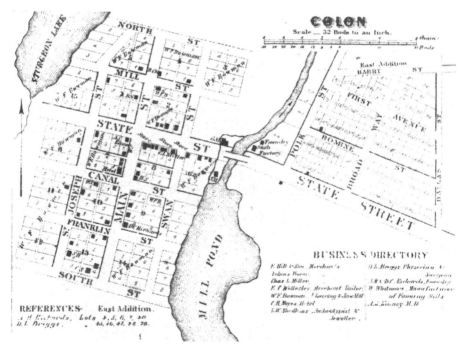

Colon Township. *Courtesy of the St. Joseph County Historical Society.*

WHY DO THEY CALL IT COLON?

Even though they are often the butt of both scatological and family-friendly jokes, Colon residents don't consider the name odd, offensive or funny. For example:

Q. What do you call someone from Chicago who lives in Colon part-time?
A. A semi-colon.

But they disagree on the origin of the name. Was it named for colon, the body part; colon, the punctuation mark; or, as Wikipedia incorrectly claims, Colon, the Spanish surname of Christopher Columbus?

It appears that Lorausi Shellhous, Colon's first postmaster, who delivered mail with assistance from eight-year-old Henry Goodwin, chose the name because Sturgeon Lake and Palmer Lake, which surround the village, resemble an anatomical colon. Here is an excerpt from *The History of St Joseph County*, published in 1877:

> *The first projectors were casting about for a name, when Lorausi Shellhous turned to the dictionary, which opening, his eye fell upon the word "Colon," and looking at its anatomical signification, said, "We will call it Colon; for the lake and the river correspond in their relations exactly to the position of the colon," and so it was named.*

Colon is known by another name: the Magic Capital of the World. This is not braggadocio, a slogan residents dreamed up to promote local industry. The United States Congress recognizes Colon as the Magic Capital of the World and celebrates the legacy of magicians Harry Blackstone and Percy Abbott. (See Senator Levin (MI), "Colon, MI: Magic Capital of the World," Congressional Record 102, Congress, S12334, August 2, 1991.)

A HUCKSTER WHO GREW RHUBARB

Although old-timers often saw him in Colon, no one knew much about Ambrose Crane, older brother of embalmer Elliott H. Crane. Some folks said he grew rhubarb, possibly in the basement of the local opera house. Others said he drove his horse-drawn cart 150 miles to Chicago to attend the World's Fair. No one is certain exactly when he was born. Perhaps 1832? Or 1833? But everyone in Colon recognized Ambrose Crane as he walked

around town. An article that appeared in the Colon Express in 1950 recalls his appearance:

> *A man, sorely crippled, supporting his body with two canes that he had himself fashioned from broom handles. Tall, black stovepipe hat which he seldom removed. Shaggy brows over piercing black eyes; dignified beard and waxed mustache.*

A dapper fellow, he added his own touch to his wardrobe; no silk scarf for Ambrose Crane: "Constantly around his neck was a heavy string, from the ends of which dangled two tin cans at his sides, containing food, which he ate when and where he pleased."

He even wore the tin can necklace to the Hill Opera House, a short walk from his tiny one-room house, where he had a lifetime lease on the upper right box, the best view in the Opera House for watching performances of *Uncle Tom's Cabin* or *The Merry Widow*. All the other boxes held six chairs; Mr. Crane's box held but one chair.

But how did he earn a living? How could he afford to purchase a house, tickets to the Opera House and a horse and pony cart? What was his occupation? According to the 1880 U.S. Census, he listed his occupation as "huckster." Ambrose Crane retired from the huckstering business and died in the county home in 1915.

AUDACIOUS AMBITIONS

As early as 1858, Colon's leading citizens took action to provide quality education to the local community under the auspices of the Colon Seminary Company, a group spearheaded by Henry K. Farrand, Phineas Farrand, Dr. A.J. Kinne, Charles L. Miller, W.F. Bowman and Adam Bower.

For ten years, the Colon Seminary taught young students, some of whom traveled a great distance to attend classes, including, among others, Michigan state senator Seth Crittenden Moffatt and mathematician John F. Downey.

At great expense to the community, students were provided with the latest educational materials in the fields of language, both English and Latin; mathematics; and music. Although subjects such as penmanship and spelling seem superfluous today, they were at the time considered part of a balanced education. Students learned mathematics despite the now

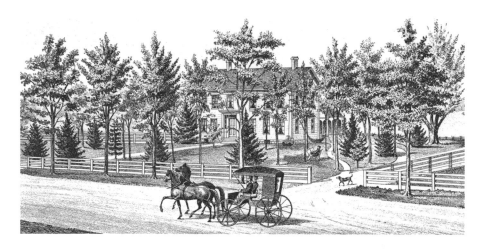

Above: The home of Henry Farrand, an early supporter of the Colon Seminary in the Village of Colon, Michigan. *Courtesy of the St. Joseph County Historical Society.*

Left: Adam Bower was an early supporter of the Colon Seminary in the Village of Colon, Michigan. *Courtesy of the St. Joseph County Historical Society.*

inappropriate content of some math problems. Here are two examples from books employed at that time:

From *Stoddard's Intellectual Arithmetic*: "If 5 pounds of opium cost $27.50, what will 20 pounds cost?"

From *Mayhew's Practical Bookkeeping*, students were asked to formulate the "expenses of an habitual smoker and chewer of tobacco."

Despite its success, not everyone in the field of education believed in the viability of the Colon Seminary. In 1867, the *Michigan Teacher* criticized Colon citizens for their "ambition to patronize Colon Seminary":

William Eck was a stockholder in the Colon Seminary. *Courtesy of the St. Joseph County Historical Society.*

The only thing valuable in connection with this institution, is the brick building which has been erected....It will stand as an imposing monument of the folly of those who want something better than a Union School. Of course, persons and corporation have an undisputed right to erect as many such Seminaries as they choose, and in large towns they may be both useful and necessary; but in such places as Schoolcraft and Colon they have no proper reason for existing.

Times have changed. Teachers no longer ask students to compute the cost of twenty pounds of opium or estimate the annual consumption of tobacco, smoked or chewed, by a habitual user.

The Colon Seminary is closed, replaced by the Colon Community Schools; however, the building still stands in the center of town, part of the Lamb Knit Mill.

A portion of the Colon Seminary was expanded as the Lamb Knit Mill in the Village of Colon, Michigan. *Photo by the author.*

HOW TO MAKE A PUMPKIN PIE

In the 1870s, more than one million housewives in the United States, Germany, France, Spain and Arabic-speaking countries wouldn't dream of setting a table, entertaining guests or baking a pie without first thumbing through the pages of the Common Sense in the Household series of books written by Marion Harland, the Martha Stewart of her day.

The domestic goddess dispensed advice on dealing with servants:

> *Like begets like. Pleasant words are more likely to be answered by pleasant than are tart or hasty ones. If you would have your servants respectful to you, be respectful to them. The best way to teach them politeness is by example.*

On how to stop bleeding: "Bind the cut with cobwebs and brown sugar, pressed on like lint. Or, if you cannot procure these, with the fine dust of tea. When the blood ceases to flow, apply laudanum [opium]."

On how to clean a rusty knife: "Use wood-ashes, rubbed on with a newly cut bit of Irish potato. This will remove spots when nothing else will."

And she divulged a secret ingredient for making the best pumpkin pie in the world. She obtained from her grocer on the East Coast "a small box of what looked like yellow-tooth powder" and smelled like

> *vanilla and orris-root…The pies made from it were delicious beyond all*
> *my former experience in Thanksgiving desserts…a soft, smooth, luscious*
> *custard…the flavor upon the tongue fully justified the promise of the odor*
> *that had bewitched me. Try it, and bear witness with me to its excellence.*

What was the secret ingredient that commanded the attention of this expert baker? Pumpkin flour. But not any pumpkin flour would do. Marion Harland used only pumpkin flour made by the Alden Fruit Factory in Colon, Michigan.

The factory, built by Charles L. Miller Jr. in 1874, employed thirty-five seasonal workers who prepared thousands of pounds of pumpkins using the Alden process, which, at that time, the Illinois State Horticultural Society claimed produces "dried fruit of a quality so far superior to that dried in the old way (by spreading in the sun)…a very superior article is produced, closely resembling fruit in its fresh state."

With a ready supply of pumpkins grown on local farms and a strong testimonial from Marion Harland, it is not surprising that the little factory in Colon flourished.

LAKESIDE CEMETERY

The Lakeside Cemetery in Colon, Michigan, is much like other small-town cemeteries built long ago as the final resting place for early settlers whose names craftsmen chiseled in stone. This peaceful cemetery, established in 1832 along the banks of Sturgeon Lake, buried its first arrival, eight-year-old Emily Noyes, the following year.

Here you will find gravestones bearing the names of Lorausi Shellhous, who gave the village its name; Charles Miller, whose pumpkin flour was known by cooks around the world; and Henry K. Farrand, to whom Colon owes a debt of gratitude for his support of education and transportation, as well as hundreds of other graves of family members who lived in Colon.

Most of the gravestones are simply marked: name, date of birth, date of death, relationship to others and perhaps a few words from a prayer.

What is unusual about Lakeside Cemetery are the peculiar phrases written in stone to remember some of the deceased. "The Magnificent Fraud," reads the headstone of Bill Baird. "Ricki Dunn, America's Greatest Pickpocket" reads another, and "The Conjuring Humorist" appears on the grave of John Jones. These are the grave sites of famous magicians.

Colon is the final resting place of more magicians than any cemetery in the world. Some of these magicians performed at magic conventions in

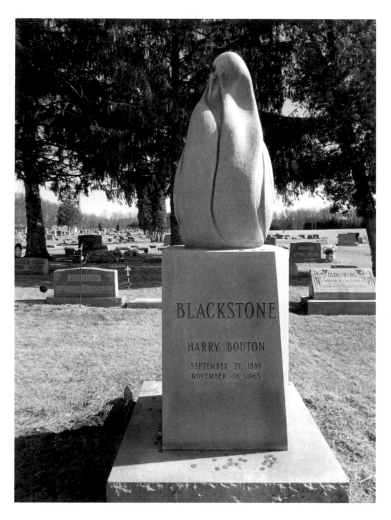

Magician Harry Blackstone is buried in Lakeside Cemetery in Colon Township, Michigan. *Photo by the author.*

Colon; other magicians lived here while not on tour and some—who never set foot in Colon—left instructions to their families requesting burial in Colon, often on Halloween, the day Harry Houdini died and promised to return. Professional magicians are celebrated with a "broken wand ceremony" conducted by local magicians, who recite an oath as they break a magic wand symbolizing that the wand has lost its magic.

Visitors to the Lakeside Cemetery place coins, decks of cards and stuffed rabbits on the gravestones of these famous magicians. The largest collection of memorabilia usually appears at the grave site of Harry Bouton, known by his stage name Harry Blackstone. Harry Blackstone and Percy Abbott, famous around the world for their dazzling performances, formed a partnership that brought magic to Colon. Oddly, Percy Abbott is not buried in Colon; the location of his final resting place is unknown.

Watch Me Pull a Rabbit Out of My Hat

Harry Blackstone, a contemporary and rival of Harry Houdini, is credited as the first magician to pull a rabbit out of a hat. Many rabbits. Many hats. And he gave stuffed rabbits to children. Over the course of his career, Harry Blackstone handed out more than 150,000 rabbits to kids who volunteered their assistance at his family-friendly matinees—one of these tykes grew up to become science fiction writer Ray Bradbury. In his own words, he wrote,

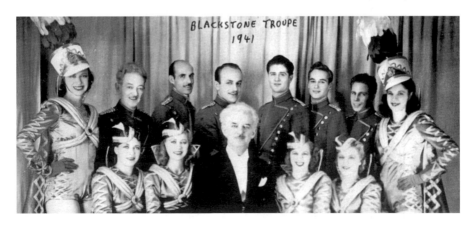

Harry Blackstone, a contemporary of Harry Houdini who lived in the Village of Colon, Michigan, inspired young Ray Bradbury, who became a famous science fiction writer. *Courtesy of the Colon Historical Society.*

"I saw Blackstone the Magician on stage and thought, what a wonderful life it would be if I could grow up and become a magician. In many ways that is exactly what I did."

But rabbits were not the only animals used by the Great Blackstone. When not traveling around the world, he brought home to Colon railroad cars filled with horses, donkeys, camels and elephants. To the delight and sometimes the dismay of Colonites, shrieks and smells of exotic animals, such as the elephants and tigers he used in his act, emitted from a private island on Sturgeon Lake dubbed "Blackstone Island." Though the animals are gone from the island, it is popular with hikers who stop to rest at the pleasant site.

3

CONSTANTINE TOWNSHIP

A TRIP FROM KALAMAZOO

If a friend in Kalamazoo drove to your home in Constantine, you'd expect him to arrive in forty-five minutes—give or take a few minutes depending on traffic flow on 131.

But before the advent of highways and county roads, traveling from Kalamazoo to Constantine was a very big deal. In 1835, Allen Goodridge of Kalamazoo received an invitation to visit a childhood friend who owned a general store in Constantine. Despite a broken leg, Mr. Goodridge set off on his journey to Constantine. Here are highlights of his trip:

> *As soon as I was able to ride I mounted an Indian pony with my crutch, and started to make the visit, on one of the latter days of September....There was nothing very attractive in the ride....I stopped at the public tavern in Schoolcraft that night, and the next morning continued my trip....I saw for the first time in my life a herd of deer feeding in their own pasture.*
>
> *I reached Three Rivers about the middle of the afternoon, exhausted with my ride, and ill. Mr. B. Moore kept a tavern there, but was absent from home, and that excellent woman, his wife, helped me to dismount, and did all she could for my comfort while under their roof. The kind attentions I received, and a sweet refreshing sleep during the night, restored my exhausted frame, and I awoke the next morning comparatively well, except my broken bone.*

Left: Despite a broken leg, Kalamazoo resident Allen Goodridge rode to Constantine, where he met John Cathcart. *Courtesy of the St. Joseph County Historical Society.*

Below: The St. Joseph River at Constantine. *Courtesy of the St. Joseph County Historical Society.*

I did not start until after ten o'clock....My journey from Three Rivers was circuitous....I was directed wrong, and might have reached Constantine some hours before I did, had I kept on the right road. But I reached it at last, much fatigued, and met a cordial reception....I stayed several days, and made the acquaintance of a number of the villagers: Judge Meek, General Ullman, W.T. House and John G. Cathcart.

It appears that Mr. Goodridge enjoyed his visit to Constantine so much that "the next spring I removed my family to Constantine."

What was the name of his storekeeper friend? John Barry, the future governor of Michigan.

FRANK DWIGHT BALDWIN

According to the U.S. Department of Defense, the Medal of Honor is the highest military decoration awarded by the United States government to members of the military. It is presented by the president of the United States to members of the military "who distinguish themselves through conspicuous gallantry and intrepidity at the risk of life above and beyond the call of duty." Since its inception, fewer than 3,500 men (and one woman) have received the Medal of Honor

President Abraham Lincoln awarded the first Medal of Honor to Jacob Wilson Parrott for his role in the Great Locomotive Chase, an audacious plot to steal a railroad engine and destroy Confederate supply lines.

President Bill Clinton posthumously awarded Theodore Roosevelt the Medal of Honor for leading the Rough Riders in the Battle of San Juan Hill.

General Douglas MacArthur, who famously returned to the Philippines, was awarded the Medal of Honor "for the heroic conduct of defensive and offensive operations on the Bataan Peninsula."

The Union soldier with a plot to decimate the Confederacy received one Medal of Honor; the man who became president, Theodore Roosevelt, received one Medal of Honor; Douglas MacArthur, a five-star general, received one Medal of Honor.

Captain Frank Dwight Baldwin of Constantine received two Medals of Honor.

Although he was born in Washtenaw County, Frank Dwight Baldwin lived in Constantine for most of his life, first as a student in Constantine's public

Frank Baldwin of Constantine received the Medal of Honor twice. *Courtesy of the National Archives and Records Administration.*

school and then as a member of Siloam Lodge, No. 35, AF&AM, before volunteering for Michigan's Nineteenth Infantry in Dowagiac.

The citation for his first Medal of Honor reads:

> *Led his company in a countercharge at Peach Tree Creek, Ga., 12 July 1864, under a galling fire ahead of his own men, and singly entered the enemy's line, capturing and bringing back 2 commissioned officers, fully armed, besides a guidon* [military flag] *of a Georgia regiment.*

The citation for his second Medal of Honor reads:

> *Rescued, with 2 companies, 2 white girls by a voluntary attack upon Indians whose superior numbers and strong position would have warranted delay for reinforcements, but which delay would have permitted the Indians to escape and kill their captives.*

Frank Dwight Baldwin ended his long military career as a resident of Colorado, but he never forgot his hometown. When Constantine needed equipment to furnish a new ten-room schoolhouse, Captain Baldwin sent "valuable mineralogical and Indian relics."

IT'S NOT EASY BEING HER SON

The Bagley family moved to Constantine from Mottville when John Judson Bagley was eight years old. His father, a tanner, worked hard to support his family. His mother, an educated woman named Olive Judson Bagley, strove for a better life. She discussed English classics and became active in the Free Soil Party, which worked to end slavery. She insisted that her children polish their shoes each morning and wear clean clothes "because every town must have some first-class children in it." John remarked, "It is not an easy thing to be the son of such a woman," but not all her words were lost on him. She instilled in him a sense of duty to his fellow man and an appreciation of the arts that shaped his time as governor of Michigan. He advocated for better treatment of poor children who commit crimes and election reform, and after his death, he provided the City of Detroit with $5,000 to build a public drinking fountain modeled after St. Mark's Basilica in Venice.

Governor Bagley moved to Constantine at the age of eight. *Courtesy of the St. Joseph County Historical Society.*

THE GREATEST EASTER EGG HUNT OF THE TWENTIETH CENTURY

On April 21, 1935, more than 3,000 people attended the Brewer family's Easter party in Constantine; most were strangers to the Brewer family, out-of-towners who invited themselves to the party. While adults assembled in the viewing area, children eagerly lined up awaiting a signal from Claude Brewer that the Easter parade was about to begin. The grand marshals, a duck and a rooster, did their best to keep time as 384 children paraded around the lawn accompanied by the Constantine School Band under the direction of Fred Waters of Elkhart, Indiana. Parents cheered as the children filed past the viewing stand; some of the children wore new outfits, and others came in costume.

Five judges—James Buswell of Kalamazoo, Myrtle Storms of Sturgis, Gertrude Reed of East Chicago, Mrs. Joseph Lasko of Centreville and Dorothy Buck of Three Rivers—evaluated costumes "most appropriate to the Easter and Spring seasons" and awarded prizes: one hundred baby chicks to first-place winner Roger Stephenson, fifty baby chicks to second-place winner Laverne Dowty and twenty-five baby chicks to Beverly Jean Hagen, who came in third.

As owners of the Brewer Hatchery, Mr. and Mrs. Claude Brewer had plenty of baby chicks to spare. They gave five thousand chicks to Chicago Municipal Tuberculosis Sanitarium in 1935—and plenty of eggs that they colored and scattered around their property on Easter morning.

Attendance grew every year. In 1936, more than five thousand guests gathered in Constantine for the Easter Egg Hunt. But after twenty years coloring and hiding thousands of Easter eggs, the Brewer family decided to call it quits. On April 1, 1945, they held their last Easter Egg Hunt.

OIL AND WATER DON'T MIX

According to geologist Garland Delos Ells, "As early as 1860 it was recognized that oil and gas bearing rocks could be found in Michigan." In 1865, a group of men formed the Constantine Petroleum Company, leased a patch of land in Constantine and began drilling. They found some oil at a depth of eight hundred feet, but there was not enough oil to make a profit. The equipment became stuck in the mud, and water gushed into the well.

Although it appeared ordinary to the naked eye, the water gave the men an idea. Perhaps they could bottle the water or entice new settlers from the East to "take the waters" in accommodations more magnificent than the world-famous spas in Saratoga Springs, New York.

They sent a sample to the Michigan Agricultural College (now Michigan State University) for analysis. The chemistry professors who examined the sample reported that the water contained a decent amount of bicarbonate of soda, magnesium, potassium and a little bit of ammonia.

The Constantine Petroleum Company reorganized as the Mineral Spring Company; the founders had plenty of water and a vision, but they had lost so much money in the failed petroleum venture that they couldn't move forward.

Luckily for the men of the Mineral Spring Company, a group of ladies from Constantine came up with a sound financial plan. The women would loan them $370, enough to kick-start the new company, if two conditions were met: allow the people of Constantine to drink for free and make a donation to local churches.

The bathhouses were built, and for decades the mineral springs of Constantine soothed muscles and nourished souls.

MR. BARRY AND THE BEETS

In 1840, Michigan state senator John Barry traveled to France from his home in Constantine to study sugar beet cultivation. Why France? Blame it on Napoleon Bonaparte. Prior to the Napoleonic Wars, France imported cane sugar from the British-owned West Indies, but when the two countries went to war, France lost its sweet supply.

But Emperor Napoleon Bonaparte had a plan to replace the tropical grass with the sugar beet, a vegetable that could be grown in France. During the English blockade of Europe, Napoleon promoted sugar beet cultivation. He established sugar beet–growing schools, and soon farmers all over France were growing sugar beets. Voila! France became a leading producer of sugar beets.

But the United States didn't have a sugar shortage when John Barry visited France in 1840. Since colonial times, fertile land provided enough sugar cane to satisfy the sweet tooth of everyone. Despite the abundance of American sugar cane in the 1840s, Mr. Barry undertook a lengthy, grueling journey to the French countryside. He would have traveled from Constantine

John S. Barry studied sugar beet growing in France before becoming Michigan's governor. *Courtesy of the St. Joseph County Historical Society.*

on horseback and spent weeks aboard a ship sailing across the Atlantic Ocean to France. But John Barry did not stay very long. By November 1841, he had returned to Michigan to begin his reign as governor of the state.

It wasn't until the Civil War that sugar production in the South came to an abrupt halt, and home bakers sought an alternative sweetener for apple pies, fruit cakes and puddings. Someone substituted sugar beets, which match cane sugar's sweetness, and because they grow underground where the earth protects them from cool weather, they don't require tropical growing conditions.

In any event, production of sugar beets didn't begin in Michigan until much later, when a professor of chemistry imported 1,500 pounds of seeds from France that he distributed to farmers across the state. Michigan's cold climate and wet soil are ideal for growing sugar beets. Today, Michigan produces 12 percent of the nation's sugar beets; the Michigan Sugar Company (a merger of six sugar beet companies) is the third-largest sugar company in the United States. Sugar beets thrive in twenty Michigan counties, but St. Joseph County is not one of them.

THREE GENTLEMEN FROM NEW ENGLAND

Civic pride, or perhaps a desire to increase circulation of their newspaper, prompted newspapermen Daniel Munger and Mr. Cowdery to pontificate on local investment opportunities available to wealthy easterners. According to *The History of St. Joseph County*:

The journalist organ of the young village discourse most eloquently on the water privileges required to make Constantine what it should be, and was destined to be, and called aloud for capitalists to come forward and establish an oil mill, edge-tool manufactory, paper-mill and blast furnace.

Soon after the *Constantine Republican* launched its first issue, three wealthy New England gentlemen decided to establish the first flour mill in Constantine. Whether they learned about this new village in the pages of the *Constantine Republican* or by word of mouth is unknown; however, they all shared in common an ambition to turn a profit, their Yankee heritage and vast sums of money.

George Howland made his fortune in the New Bedford, Massachusetts whaling industry at a time when every American family purchased products made from whales: whale oil to lubricate machinery, to make candles or to illuminate lamps; baleen for ladies' corsets; and whale teeth for piano keys and handles of gentlemen's walking sticks. Whaling was arduous, as author Herman Melville learned aboard the *Acushnet*, a whaling vessel owned by a rival New Bedford company. But owning whaling ships and letting others deal with whales proved less risky, and this is the career path George Howland chose.

Howland's business partner, statesman Daniel Webster, eagerly joined the Constantine business proposition. A well-educated man, Daniel Webster of Salisbury, New Hampshire, attended Phillips Exeter Academy, an elite high school that continues to accept only the brightest students. (Facebook founder Mark Zuckerberg graduated from the prep school in 2002.) Daniel Webster began his career as an attorney strongly in support of the federal action to stimulate the American economy through protective tariffs.

He gained a national reputation (and supplemental income) as a lecturer who peppered his speeches with memorable quotations:

"Keep cool; anger is not an argument."
"There is always room at the top."
"There is nothing so powerful as truth—and often nothing so strange."

The people of New England elected him to the U.S. Senate and the U.S. House of Representatives. He served as United States secretary of state under three presidents. Despite an annual income estimated at $15,000 (over $400,000 today), Daniel Webster lived beyond his means and often borrowed money with little intention of repaying the lender.

George Howland and Daniel Webster knew nothing about flour mills and soon dropped out of the triumvirate.

The third New Englander of the trio, Joseph R. Williams of Taunton, Massachusetts, actually knew something about running a flour mill. A gentlemen farmer, he served as the first president of the Agricultural College of Michigan, now Michigan State University. He began preparations to establish Constantine's first flour mill with the purchase of water power from William Meek.

Beginning in 1841, William Meek ran the mill, which produced twenty-five thousand barrels of flour annually. Unfortunately, an arsonist destroyed the mill in 1856, and Mr. Williams's fragile state of health declined. He died of influenza in 1861.

George Washington Bungay

In 1831, Francis Bungay, along with his wife and children, left their native England for a new life, initially landing in New York City. In 1833, they moved to Constantine, where they raised their four children: Francis Jr., Marie, Thomas and George.

Francis Sr. worked as a skilled carpenter and for a while operated Constantine's first bakery. A religious man, he joined the Baptist Church, where he and other church members raised funds to build a church.

In the summer of 1838, a fever of unknown origin spread through Constantine, claiming the lives of many of its citizens, including Francis Bungay Sr. His teenage boys worked various jobs to support their widowed mother: blacksmith, farmer and riverboat captain. Elizabeth Bungay died in 1851.

As adults, both Francis Jr. and George joined the temperance movement. Francis remained active in the local community throughout his life. George moved to New York City, where he gained notoriety as a lecturer and author.

An East Coast booking agent described his client as a man "of sparkling wit, fervid eloquence and resistless humor."

A lecture George delivered in which he urged temperance societies to band together for support resulted in a convention of temperance societies held in Boston.

George Washington Bungay wrote extensively about the evils of alcohol. In "The Herald of Heath," an essay that appeared in a national medical journal, he extolled the virtues of water.

In his spare time, he kept busy composing a campaign song for Abraham Lincoln, collaborating with Stephen Foster and publishing a body of poetry that included a forty-two-page poem about the Kansas-Nebraska Act and a brief ode to brunettes.

George Washington Bungay died in 1892.

MR. COFFINBERRY, MEET MR. APPLESEED

In 1843, Ohio attorney Salathiel Curtiss Coffinberry moved to Constantine, where he practiced law until his death in 1889. A brilliant attorney, he constructed persuasive arguments in defense of his clients. As a political candidate, he carried the message of the Democratic Party to audiences around Michigan.

An eloquent speaker, fluent in German and French, his friends remember his "powers of conversation that were remarkably rare and fascinating." The Masons of Michigan elected him their first grand master. His biographer stated, "In conversation he was peculiarly fascinating and entertaining; as an advocate he was eloquent and convincing; in public speaking brilliant and forcible."

Much of what Salathiel Curtiss Coffinberry said and wrote has been lost to history. Curiously, a persuasive argument in support of his fellow man appears not in Michigan's judicial records but in the biography of one of America's best-known folk heroes, Johnny Appleseed, the nineteenth-century horticulturist who planted apple orchards throughout the Midwest.

Contemporaries ridiculed John Chapman for his religious beliefs and nomadic existence, creating the sobriquet "Johnny Appleseed" for a silly man who wandered about the country barefoot, wearing a tin pot for a hat and a loose-fitting coffee sack as clothes.

Constantine's Salathiel Curtiss Coffinberry, who knew John Chapman when they were neighbors in Ohio, set the record straight in William Kerrigan's book *Johnny Appleseed and the American Orchard*:

> *Salathiel Coffinbury* [sic], *who knew Chapman in Mansfield, said he never saw him in in a coffee sack, but he generally wore "the off cast clothing of others." He was "often in rags and tatters, and at best in the most plain and simple robe* [but] *he was always clean, and in his most desolate rags comfortable, and never repulsive."*

While not attending to young Salathiel and her other nine children, Elizabeth Coffinberry sewed a coat for Mr. Chapman according to his design:

> *This coat was a device of his own ingenuity and in itself a curiosity. It consisted of one width of coarse fabric, which descended from his neck to his heels. It was without collar. In this robe were cut two arm holes into which were placed two straight sleeves.*

John Chapman never did get to see Salathiel's success in St. Joseph County. He died in Fort Wayne two years after Salathiel Coffinberry moved to Constantine.

FABIUS TOWNSHIP

THE ALCHEMIST OF FABIUS TOWNSHIP

According to the Michigan Department of Natural Resources (DNR) website, Corey Lake's fish species include carp, crappie, largemouth bass, northern pike, smallmouth bass, sunfish, walleye and yellow perch, and in the spring and early summer, bluegills are found in shallow water. And because much of the shoreline is privately owned, the DNR suggests, "It is best to have a boat."

That is exactly what Hezekiah Thomas concluded more than one hundred years before the creation of the DNR. Day after day, Mr. Thomas hauled his boat to the middle of Corey Lake to fish, but he was not fishing for bluegill or walleye. Mr. Thomas sat in his boat, naked and without sunscreen, listening and watching; spirit voices told him to watch for a huge fish, species undetermined, filled with diamonds. Day after day, the naked man rowed around Corey Lake armed not with a fishing pole but with a gun and dagger. When neighbors complained about Mr. Thomas's lack of attire, he donned a business suit, stuck a high silk hat atop his head and continued to watch.

He was not successful, but with his faith in unreliable spirit voices still intact, he changed tactics. Hezekiah Thomas set about collecting pebbles that, according to the voices, would soon turn into gold. He brought home bushels of pebbles—so many that the Knevel family who bought the house after Mr. Thomas froze to death spent their early days in the home extracting pebbles.

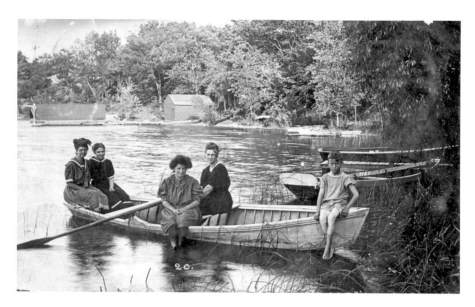

These ladies and their young friend posing in Corey Lake are most likely unaware of a claim that a fish filled with diamonds swims in the lake. *Courtesy of the St. Joseph County Historical Society.*

Did Hezekiah Thomas find any treasures? Maybe.

According to a report in the *Bismarck Tribune* on July 6, 1911, boys digging a hole for a flagstaff at Camp Eberhart found an iron box and a note that read, "This chest is the property of Hesekiah [*sic*] Thomas, formerly of New England, later of Michigan wilderness."

What did the newspaper report say was found in the box?

> *Two rusty pistols of ancient pattern, then a motley collection, including a silver-cased watch of Swiss manufacture, small dagger and rust-stained hunting knife, leather bound books dating from 1767 to 1819, among them a Bible, a number of pennies bearing dates from 1781 to 1854, samples of silver, lead and copper ores, arrowheads, and a collection of gold pebbles.*

Wait, what? Gold pebbles? Those spirt voices weren't kidding! Maybe that huge fish filled with diamonds still swims in Corey Lake today. Forget about walleye and sunfish. Keep an eye out for the diamond fish.

THE GIRL SCOUTS OF LITTLE LATVIA

The Girl Scouts of Oak Park, Illinois, could not have made a better choice than Dr. Louise Price to guide the troop in their search for a parcel of land suitable for their new summer camp. A psychologist, school counselor and author, Louise Price served as the National Girl Scout camp director for the Girl Scouts of America during the 1920s.

At the request of the suburban troop, she inspected, and rejected, four Midwest sites that did not meet her criteria: a naturally beautiful site with woods and a lake located not more than a few hours' drive from Chicago. Her long search for the perfect parcel of land ended one winter in Fabius Township, where through drifts of snow she imagined a site on Long Lake as it would appear in warmer weather. She proclaimed it the "ideal camp site."

Girl Scout Camp Lone Star opened in Fabius Township in 1927. According to reports from the Girl Scouts of America, the first group of scouts led by Miss Mildred Marsh "tumbled out of buses at and onto the camp ground where the hungry girls devoured tasty sandwiches prepared by local cooks."

Not all hungry girls enjoyed the bill of fare at Girl Scout Camp Lone Tree. The following year, several girls were taken to a local hospital, suffering from ptomaine poisoning—an event so disconcerting that the news was dispatched via telegram to Chicago newspapers:

> *Pioneer unit of Camp Lone Tree suffered from ptomaine poisoning following a breakfast out of doors Sunday morning.*
>
> *The following girls were taken to the hospital for better care, Jean Buchanan, Mary Jane Parks, Katherine Hoffman, Rose Labond, Grace Simons, Katherine List, Dorothy Downs, Laura Smith, Isabel Kennedy.*

Bad luck plagued Camp Lone Tree again in 1941, when 129 girls returning to Chicago were ordered quarantined by Illinois health officials because of exposure to polio.

In 1965, the Girl Scouts sold the camp to a Latvian cultural organization that continues to operate today. Renamed Latvian Center Garezers (Garezers is Latvian for "Long Lake"), the two-hundred-acre camp serves as a gathering place for the celebration of Latvian culture, heritage and language.

Today, the Latvian camp operates approximately one hundred buildings: cabins, classrooms, a dining hall, museums and a library.

THE PRIVIES OF JOHNNY CAKE PRAIRIE

Garrett Sickles and his family lived on Johnny Cake Prairie in Fabius Township. *Courtesy of the St. Joseph County Historical Society.*

Heman Harwood lent his home for an early government meeting in White Pigeon Township. *Courtesy of the St. Joseph County Historical Society.*

In 1830, Garrett Sickles and his family chose as their homestead Johnny Cake Prairie, a flat little prairie in White Pigeon Township. Ten years later, when the Michigan legislature divided White Pigeon Township, Fabius Township took control of Johnny Cake Prairie. Johnny Cake Prairie's break in thick forests of beech, maple, oak, walnut and elm trees proved fortuitous for farmers.

Mr. Sickles did well. In 1841, at a government meeting held in the home of Hiram Harwood on Johnny Cake Prairie, Mr. Sickles was appointed road commissioner.

But as the settlement on Johnny Cake Prairie grew, environmental contamination in nearby towns followed. In 1890, at the request of Mr. L.A. Aspinwall, president of the Village of Three Rivers, a team from the Michigan Board of Health examined water supplied to Three Rivers. In a report, the examiners identified the source of the potential typhoid epidemic: rain falling on Johnny Cake prairie, which

has had the opportunity to receive the leachings from privies near quite a number of residences, at any one of which there may sometime be a case of typhoid fever or some other

disease capable of being spread by leaching of contents of a privy into the water-supply. (It is well to bear in mind the difference in results where such cause of disease finds it way into a private well in which case only a few are made sick, and into a general water-supply of the village in which case hundreds or even thousands.)

Considering, as I do. that there is probably a general and constant movement of the water in the ground (down to a depth near the level of the pond and river) the movement being from the distant hills, and a few feet under the surface of the wide plain [Johnny Cake Prairie] *toward the pond and river I think that a shallow well near the pond or river, would not be a safe source for a water-supply, even if analysis proves the water to be now free from organic matter; because of the liability of some privies in the course of the constant general current toward the river, contributing at some future time the unseen cause of typhoid fever.*

Fortunately, the Board of Health recorded only a few cases of typhoid fever in St. Joseph County in subsequent years—none in Fabius Township.

Spiritual Renewal

In the fifth century, a young man named Benedict rose so quickly through the ranks of an Italian abbey that other monks became jealous. He was a stern leader, and according to a biography by Pope Gregory I, because of his rigid ways, his fellow monks decided to poison his wine. Fortunately for Benedict, the wine glass shattered as he prayed over it, spilling the wine and saving his life. Next, the monks baked a loaf of poisoned bread, but a raven carried it away, saving the life of the soon-to-be saint.

Benedict forgave the men for their crimes, but taking no chances, he left the abbey and retreated to life as a hermit in the Italian mountains. In later years, he returned to civilization and established twelve monasteries, setting the foundation for monastic communities in Europe.

He died a peaceful death at age sixty-seven, and the Roman Catholic Church elevated him to sainthood.

In 1935, a group of Episcopalian men traveled from a Wisconsin seminary to a Benedictine monastery near London, England, with the intention of forming their own monastery in the United States. But England declared war against Germany four years later, and the men returned to the United States.

St. Gregory's Abbey in rural St. Joseph County offers short stays in a quiet setting. *Courtesy of St. Gregory's Abbey.*

In 1946, they purchased a woodsy plot of land in Fabius Township that contained two farmhouses and several war surplus buildings known as Quonset huts. Through donations and sweat equity, St. Gregory's Abbey became a simple but modern compound in a tranquil, lakeside setting.

Monks at St. Gregory's Abbey live their lives according to Benedictine rules: work, silence, humility and obedience. Aspiring monks spend several years studying before making a lifelong commitment to the abbey.

Today, the Abbey welcomes guests, both men and women, who desire to worship in the monastic environment for a few days. Visitors sleep in Spartan, but comfortable, guesthouses and attend religious services with the monks.

5
FAWN RIVER TOWNSHIP

Map of Fawn River Township. *Courtesy of St. Joseph County Historical Society.*

THE MAN WHO BELIEVED IN A STRONG MILITIA AND LOWER TAXES

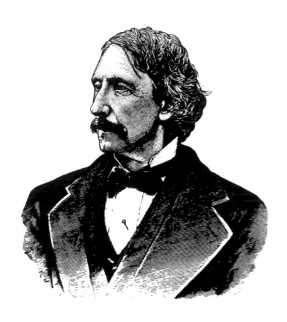

Isaac Toll of Fawn River lowered taxes in St. Joseph County. *Courtesy of the St. Joseph County Historical Society.*

Throughout his life, Fawn River Township resident Isaac DeGraff Toll advocated for a strong militia and lower taxes.

As a member of the Michigan House of Representatives, he successfully persuaded the legislature to establish an active militia, contending that "patriotism and military ardour alone, except in cases of actual hostilities, are but idle words."

In 1847, he trained twenty-five men from St. Joseph and Kalamazoo Counties in the fields of Fawn River, transforming them into what would become the brave soldiers of Company E of the Fifteenth Regiment of the U.S. Infantry. Within a few weeks, Company E faced the enemy in Mexico. He praised his Fawn River neighbors, Horace, Levi and Theron Bartholomew, brothers "among the first to enlist for the war."

Captain Toll wrote in his memoirs:

With the drum-major Francis Flanders [Jr.], of Fawn River, that peacock of all drum-majors, and as brave as a Caesar, who had served throughout the Seminole war; and fifteen of my company [ten men were already dead] I was first of the regiment to our encampment at River San Juan....Many a soldier, overcome with heat, threw away his knapsack, for it was a question of life of death....Resting the next day, and the day after, going by several unburied bodies blackened by the sun, we proceeded to Paso del Ovejas.

For his military service, Isaac D. Toll received a pension of twelve dollars per month.

After returning to Fawn River, Isaac Toll addressed the issue of taxes assessed by the State of Michigan. St. Joseph County paid more than the surrounding counties: Branch, Calhoun, Kalamazoo and Cass.

In the 1876 Proceedings of the State Board of Equalization, he stated:

> *It* [St. Joseph County] *is not all lovely, as swamps, marshes, and lakes diminish the productive area. The county is denuded of timber, and as a consequence, the production of wheat is not so great as in other counties of similar soil, where the farms are protected by forests. The average of the wheat crop of St. Joseph County is ten bushels per acre; while that of the State is thirteen bushels per acres. The towns on the border of Cass and Kalamazoo have been assessed twice as high as those on the other side of the county line.*

Persuaded by Isaac DeGraff Toll's simple but effective argument, the State of Michigan reduced taxes in St. Joseph County.

FENCES OF FAWN RIVER

In 1914, poet Robert Frost wrote, "Good fences make good neighbors," long after officials in Michigan determined that good neighbors with good fences occasionally needed guidance from Lansing.

On April 2, 1838, in compliance with Michigan law, the Village of Fawn River elected two "fence-viewers": Isaac Culver and tavern owner Ebenezer Sweet. As fence-viewers, the two men decided where fences could and could not be built, they inspected fences, ordered owners to make repairs, imposed fines and mediated disputes between neighbors. For this, they were paid one dollar per fence viewed.

Their duties included the dangerous work of rounding up—and often being chased by—cattle allowed to roam free. They soon learned to identify the bovine culprits by their markings. W.W. Plumb slit the left ear of his cattle twice and the right ear once. F.A. Tisdel slit only the left ear; Lemuel Graham slit only the right ear.

If Sweet or Culver did not view a fence as directed by the State of Michigan, they were fined five dollars per unviewed fence.

FRANCIS FLANDERS OF FAWN RIVER

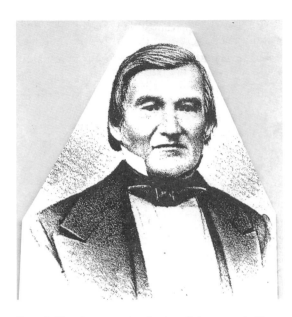

Francis Flanders served as justice of the peace in Fawn River. *Courtesy of the St. Joseph County Historical Society.*

Francis Flanders lived a quiet life in Fawn River, supporting his wife and seven children as the owner of a woolen mill, enjoying popularity among the citizens of Fawn River as an elected official, yet a brush with two public scandals not of his own making brought unwanted notoriety.

A young Fawn River couple, whose names are not recorded in history, appeared before Justice of the Peace Francis Flanders with a common request: perform a marriage ceremony post haste. The quiet wedding, which most likely took place in Mr. Flanders's home, and the celebratory meal should have gone unnoticed by the Fawn River community; however, a group of young men made certain that this did not happen. During the wedding feast, "the boys celebrated the nuptials with a discharge of artillery… which made no inconsiderable racket in the vicinity." At the close of the day's festivities, the young men gathered together to perform a charivari, a serenade accompanied by cowbells and fiddles that lasted into the night. Whether Mr. Flanders regretted his decision to unite the newlyweds in marriage is unknown; however, his neighbors, endangered by stray bullets fired by drunken revelers, may have wished he hadn't.

In 1850, fishermen found a corpse floating in a millpond and brought the death to the attention of Francis Flanders, who impaneled a coroner's jury that determined the cause of death: "found drowned." With thirty-eight dollars retrieved from the corpse's pocket, the town commissioned a local man to make a coffin and laid the stranger to rest in the Fawn River Township Cemetery.

But that was not the end of the matter. Soon after the stranger's funeral, rumors spread across St. Joseph County that something untoward had

occurred in Fawn River. Was the man murdered? Did Fawn River officials, including Francis Flanders, cover up a crime?

A mob of 150 St. Joseph County residents "invaded the peaceful precincts of the village and impaneled another jury, exhumed the body and reviewed it again officially." Members of the new jury came to the same conclusion: death by drowning

Francis Flanders served as justice of the peace for sixteen years and for two years as town clerk without further notoriety.

A Whole Latta Counterfeit Money

In the 1850s, a family of counterfeiters operated in Fawn River Township, printing money on presses purchased from Sturgis blacksmith shops. The Latta family lived on a farm on Chicago Road that was later seized by the county for a poorhouse, but not before N.B. Latta, a notorious counterfeiter who printed over $25,000 in counterfeit money, convinced a judge that he was actually a Pinkerton detective working on the case. The property was also the site of the murder of Constable Gamaliel Fanning, who attempted to arrest a gang of horse thieves.

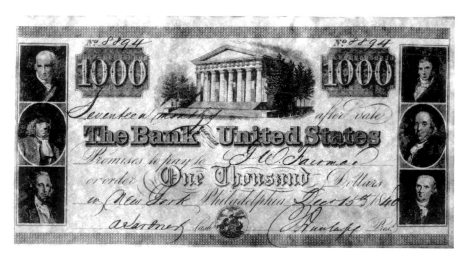

An example of counterfeit money printed in St. Joseph County. *Courtesy of the St. Joseph County Historical Society.*

FLORENCE TOWNSHIP

ALVIN AND HIS ARKS

With over 150 miles of waterways, more than any other county in Michigan, St. Joseph County residents are familiar with the agony of "two-foot-itis": the unremitting desire of a boat owner to obtain a boat that is two feet longer than the one he owns.

But bigger isn't always better. Take for example what happened in the 1830s. As farms developed and mills flourished, an

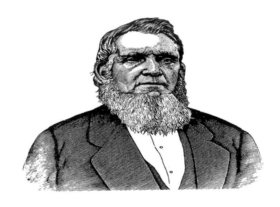

Alvin Calhoon of Florence Township built arks able to navigate the St. Joseph River. *Courtesy of the St. Joseph County Historical Society.*

abundance of flour, more than was needed locally, had to be transported to other markets. Roads were bad or nonexistent in parts of the county (just ask Alvin Calhoon, a Florence farmer with a brood of seventeen children, who rode on horseback chopping branches with an axe as he and Robert Clark Jr. blazed a road to Constantine), but the St. Joseph River was always flowing. What better way to ship flour than on a—well, on a ship?

Huge box-shaped boats called arks began to appear on the river, each carrying from four to six hundred barrels of flour. But size was a problem. As one owner said: "It was not bad going downriver, but the return was sometimes 'fierce.'" More often than not, the boat owners chopped up their watercraft, sold the timber and returned home to build another boat.

Alvin Calhoon, about whom it was said "once he assumes a stand on any question, he never wavers, but sticks to the principles he advocates through thick and thin," dedicated himself to ending the waste of lumber by building a fleet of smaller arks, each carrying twenty barrels of flour, which he hauled home by wagon.

Peppermint Wars

Today, we think of peppermint as a breath freshener—brush your teeth, chew gum or suck on candy and hope that no one in that important meeting notices what you ate for lunch. We also think of peppermint at Christmas. Who doesn't love those red- and white-striped candy canes? But that's about it.

While we don't think about peppermint often, this fragrant herb helped boost the economy in Florence Township, reaching an annual output of four thousand pounds of peppermint oil grown on three hundred acres.

Calvin Sawyer of Ohio brought the first peppermint plants to St. Joseph County. He tried to grow mint in White Pigeon, but strong winds rushing across the prairie destroyed most of the plants. Within a year, he sold his plants to two farmers, Mr. White and Mr. Earl, who attempted to grow them on their property in White Pigeon. Once again, nature did not cooperate.

In 1838, Lewis Ranney and Marshall Orrin Craw planted peppermint roots in the burr oak openings of Florence Township, where, protected from the wind, crops flourished. According to the *History of St. Joseph County*:

> *The burr oak openings production was quite successful; the peppermint plants required less cultivation than on the prairies, and winterkilling was not a great a problem.*
>
> *Cultivation on the prairies was soon discontinued and, for some years, peppermint raising in Michigan was confined largely to the burr oak openings of Florence Township.*

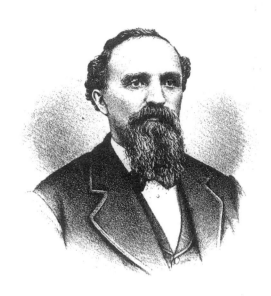

A.P. Emery (right) and Norman Roys produced mint of high quality in St. Joseph County. *Courtesy of the St. Joseph County Historical Society.*

A. P. EMERY.

Reuben and Otis Matthews opened a mint oil distillery, firmly establishing Florence Township as America's top producer of both peppermint and spearmint, outselling rivals in Ohio and New York.

As medical professionals, both quack and reputable, began to recommend peppermint potions to their patients, demand for the oil in the United States and Europe increased. Charles Frederick Millspaugh, a Cornell-trained physician and highly regarded botanist for whom a genus of plants is named, recommended peppermint to treat flatulence, vomiting, diarrhea, neuralgia, sciatica, kidney stones, bladder stones and a host of other ailments. In 1869, Ohio dentist William F. Semple recommended chewing gum to strengthen the jaw.

For a time, New York peppermint oil exporter Hiram Hotchkiss attempted to monopolize the sale of peppermint oil grown in the United States by guaranteeing Florence Township growers $2.50 per pound and then using their cooperation as a bargaining tool with growers in New York. A.P. Emery and Norman Roys produced mint of high quality.

The system worked well for a few years, until a weed popped up in Florence Township, nearly destroying its reputation for growing high-quality peppermint oil.

The weed, known as mare's tail, field broom or fireweed, spread through mint crops, and as James E. Landing wrote in *American Essence,*

The Todd brothers of Nottawa Township produced a peppermint oil superior to all others. *Courtesy of the St. Joseph County Historical Society.*

many growers simply let the weed grow, cut it with the mint and distilled it. As a result the bulk of Michigan product contained a large proportion of fireweed oil....This led very early to the general opinion that the "western" [Michigan] *oils were inferior to those produced in New York.*

The Todd brothers of Nottawa fought to restore the reputation of local growers by exposing the inferior distillation of New York mint oil and promoting their locally distilled Crystal White oil. In the 1876 Centennial Exposition of the United States, held in Philadelphia, one of the Todd brothers won an award for his Crystal White Peppermint Oil and the newly developed peppermint lozenges.

THE STRANGE CASE OF MR. STRANG

Jesse James Strang suffered throughout his childhood. Teachers thought him too stupid to learn. Fellow students taunted him. In his autobiography, he recalled that memories of his childhood "produced a kind of creeping sensation akin to terror." Undiagnosed illnesses laid him so low that his parents, thinking he was dead, made preparations for his burial. Yet he lived long enough to father fourteen children by five wives.

On August 5, 1844, Jesse James Strang, who by this time had changed his name to James Jesse Strang, stood before a gathering of the Church of Jesus Christ of Latter-day Saints, also known as the Mormon Church. Well known to church elders, although baptized just six months earlier, those who didn't know him were undoubtedly struck by his appearance.

Described by a contemporary:

He wore a very heavy beard of reddish tinge, and his hair was red, too. He had dark eyes that looked at one on occasion as thought they could bore right through. They were set close together, under wide projecting brows, from which rose a massive forehead. Add to this a thin hatchet face, and you have a grouping of features that would attract attention anywhere.

Despite his frail condition, he traveled across the country. Strang walked three hundred miles to attend a meeting in Florence Township, and a letter Mr. Strang produced at the Florence Township meeting changed the Mormon Church forever.

Following the murder of Joseph Smith, founder of the Church of Christ of Latter-day Saints, on June 27, 1844, saddened church elders sought to appoint a successor. Some thought Joseph Smith III, the founder's son, the only logical successor. Others who gathered at church headquarters in Nauvoo, Illinois, preferred Brigham Young.

James Jesse Strang thought himself to be the best possible choice as the church's new leader. He produced a letter written by Joseph Smith, postmarked June 18, naming Strang as the new leader of the church and directing him to relocate the church from Illinois to Wisconsin.

Not everyone at the Florence meeting was convinced of the letter's authenticity. Why would Joseph Smith choose a successor while he was still alive, nine days before his death? Why was there no record of the correspondence in the church's register of mail in Nauvoo, Illinois?

Following the death of Joseph Smith, Brigham Young became the leader of the Mormon Church, and years later, he relocated the church and its followers to Utah.

And what happened to James Jesse Strang? He left Florence Township and established his own sect, which had thousands of followers, including members of Joseph Smith's family. He moved to Beaver Island, Michigan, where in a ceremony in which he wore a tin crown and carried a wooden scepter, he proclaimed himself "King of the Kingdom of God on Earth." He continued to practice polygamy until 1856, when he was murdered by his followers.

FLOWERFIELD TOWNSHIP

FLOWERFIELD LAYS DOWN THE LAW

In the early 1830s, the residents of Flowerfield Township, which at that time was larger than its present size of six square miles, got busy in Joshua Barnum's home organizing local government.

The first order of business: trespassing hogs. Any male pig weighing more than twenty pounds found trespassing could be castrated by anyone.

Next: wolves. Flowerfield would pay a bounty of one dollar for the scalp of any wolf caught within the township. To pay the bounty, the township raised taxes by five dollars (the same amount spent aiding the poor).

And then they addressed the lack of roads. No longer would settlers drive their horses and buggies over neighbors' farms. Road commissioners Henry Garver, George Nichols and Robert Gill hired surveyors Mr. Briggs and Mr. Nichols to examine an old trail that they would establish as the township's first road.

With anarchy avoided, Flowerfield's 406 residents got busy building their community. Three young bachelors—Abram Vandemark, Henry Kinney and David Hamilton—opened a distillery in the village. Challenge Wheeler ran the post office. Mishael Beadle built Flowerfield's first mill and rebuilt after a raging fire destroyed it. Malvina Nichols taught school. Benjamin Taylor preached the first religious sermon in Joshua Barnum's tavern.

Reverend Taylor, who suffered from poor health, did not stay long in Flowerfield; he left Michigan to join family on the East Coast, breathing in fresh sea air while he convalesced. While no transcript of his barroom sermons exist, we can assume from an essay written by a bestselling author who attended one of Taylor's sermons on the East Coast that he was a remarkable speaker. In 1854, Fanny Fern, one of the highest-paid writers in America, wrote about shedding tears during a sermon Taylor preached to salty sailors in Boston.

Franklin Howard donated $600 to build a school, and for a few years the land around his sawmill was known as Howardville or Howardsville. But shortly after his death, a post office was established, and the town became known as Tinker Town, or Tinkerville, in honor of Chauncey Tinker, the first postmaster. Mr. Tinker, a veteran of the War of 1812, is buried in the Howardsville Cemetery.

ROLL OUT THE BARRELS

Pioneers who came to Flowerfield in the 1830s set about creating a village to satisfy the needs of everyone in it. Mishael Beadle sold produce grown

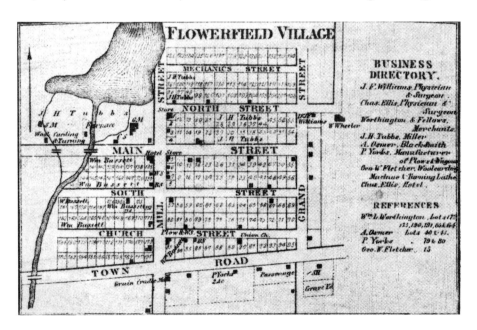

Map of Flowerfield. *Courtesy of St. Joseph County Historical Society.*

on his farm, the first in Flowerfield. David Beadle built a gristmill, which put an end to the arduous task of grinding grain in a coffee grinder. Mr. Wheeler ran the first general store and planted an orchard, the fruits of which would nourish future generations. Sam Foley shoed horses in his blacksmith shop. Malvina Nichols taught the village children how to read. Dr. C.L. Clewes attended to the sick, and those who didn't survive were buried on an acre of land James Brown donated for a cemetery. Joshua Barnum's tavern near Mr. Wheeler's stores bustled with activity, albeit lubricated with liquor.

The only amenity lacking in this village of God-fearing men and women was a church, which they did not have sufficient funds to build. But this didn't stop the Flowerfield citizenry from worshipping on Sundays. Until the first church was built in 1853, the villagers worshipped in Mr. Barnum's tavern. Cognizant that Michigan liquor laws prohibited the sale of alcohol near a house of worship, the churchgoers rolled the liquor barrels outside each Sunday, just far enough away from the tavern for them to remain law-abiding citizens.

The Flowers of Flowerfield

When choosing a name for a township in the northwest corner of St. Joseph County, surveyors walked through abundant fields of flowers and chose to call it Flowerfield. So breathtaking were the flowers in the fields that botanist Ruth Hoppin, for whom the Three Rivers elementary school was named, said: "I have not words sufficient to adequately picture them."

Though at a loss for words, the young botanist compiled a list of the flowers she saw here:

> *Blue lupines, variegated phlox, scarlet painted cups, purple and white erigerons, purple cranes' bills, blue spiderworts, yellow cynthias, rock roses, golden alexanders, white meadow rue, galunis, coarse columbine, medical lady slippers, seneca snake root, in wildest profusion and stretching as far as the eye could see.*

Ruth Hoppin also noted flowers no longer growing in abundance when she observed the fields in Flowerfield: "Why try to describe the earlier growths of violets, buttercups and anemones." She rebuked farmers for

Botanist Ruth Hoppin observed *Polygala senega*, commonly known as Seneca snake root, growing in abundance in Flowerfield Township. *Courtesy of the United States Department of Agriculture.*

"their eagerness to subdue the soil."

And she wondered, "Must the native flowers of St. Joseph County follow the buffalo, the deer, the wild pigeon and the prairie hen into the things of the past? Must the day come when there shall be no patch of forest where a child may see the flowers which charmed the parents' eyes?"

In a history of St. Joseph County written in 1877, the author describes Flowerfield and neighboring townships as follows:

All undergrowth obliterated as though a gardener had passed through with axe, spade and rake…the whole surface was carpeted with a rank growth of rich grasses and beautified with myriads of flowers of various hues and forms.

If she were alive today, Ms. Hoppin need not worry—the natural beauty of Flowerfield remains, enhanced by the development of farms.

LEONIDAS TOWNSHIP

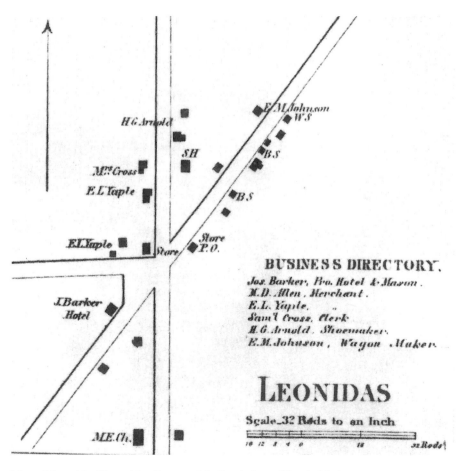

Map of Leonidas Township. *Courtesy of St. Joseph County Historical Society.*

THE MEN WANTED WHISKEY BUT HE GAVE THEM COFFEE

William H. Cross told the Pioneer Society that he "knew nothing of pioneer life" when he left New York State in 1825. But Cross was nothing if not a quick learner.

His first attempt to build the first dam across the St. Joseph River ended in disaster: "He saw the wild rush of waters take away the labor of weeks, and with it his hard earnings of years."

A strike almost derailed his second attempt when newly hired laborers threatened a work stoppage because Cross refused to provide whiskey to the crew. But in the end, the men relented.

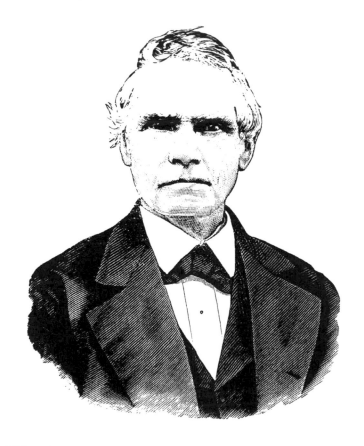

William Cross did not provide whiskey to the men who built a dam on the St. Joseph River, and they threatened to quit. *Courtesy of the St. Joseph County Historical Society.*

When construction was completed, Cross asked the men why they relented. One man offered the following explanation:

> *Well, I did not mean to do so, because I supposed you would stand on the bank in dry clothes and "boss" the job, but when I saw you jump into the water the first of all, and stay there, till all the rest were out, I was ashamed and said I would not be beat by a little fellow like you, and now I don't care for whisky. Besides, you gave us good coffee five times a day, and treated us like gentlemen.*

William Cross built a mill on the St. Joseph River, but with his funds depleted from construction of the dam, he couldn't afford to operate the business.

Always resourceful, he joined the '49ers digging for gold in the California hills, where he made a small fortune. Upon his return to St. Joseph County some seven years later, he reinvented himself as a public servant, earning a reputation for fairness as a probate judge.

FELIX BALDERRY

Approximately 75 percent of the 2 million soldiers who fought for the Union army were born in the United States; 500,000 were foreign born; and fewer than 30 were born in the Philippines. One of these Filipino soldiers lived in Leonidas.

Leonidas farmhand Felix Cornelius Balderry enlisted in the Eleventh Michigan Infantry on December 7, 1863, at Kalamazoo and bravely fought at Buzzard's Roost, Resaca, New Hope Church, Kennesaw, Ruff's Station and the Siege of Atlanta. His commander, Colonel William L. Stoughton, considered him an "intelligent and faithful soldier."

Though Private Balderry was a small man, only five feet, four inches tall and 110 pounds, First Lieutenant Stephen P. Marsh thought him "tough and hearty a boy as there was in the country." On a forced march through the Etowah River, he became feverish and could not keep up with his regiment. He received emergency medical treatment behind enemy lines, yet his condition worsened. By the time he was admitted to a hospital in Chattanooga, Tennessee, his left arm and side were paralyzed.

In an affidavit for government compensation, Marsh stated:

There was a severe rain storm the last days of June, 1864, while on the battlefield, had been more or less engaged in battle with the enemy. We had no tents or shelter and I well remember that the claimant [Balderry] contracted a severe cold from exposure which settled on his lungs and in his throat and on the third day of July 1864 I saw the claimant and well remember that he coughed a good deal and complained to me that he was sore and distressed in the lungs so much so he was left behind, could not march with the regiment.

Upon receiving a medical discharge, Balderry returned to Joseph Foster's farm in Leonidas. Still suffering from partial paralysis and weakened by a respiratory illness, he was no match for the rigors of farming, but this mattered little to his employer. Joseph Foster and Felix Balderry had forged a lifelong friendship that began in the South Pacific, when the Filipino teenager served aboard a merchant ship Foster commanded. After Foster retired from seafaring, he brought the boy to Leonidas, where he lived with

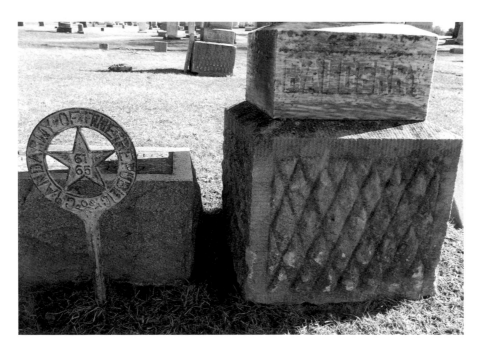

Felix Cornelius Balderry of Leonidas is one of only a few Civil War soldiers born in the Philippines. He lived most of his adult life in Leonidas. *Photo by the author.*

Foster's family. With Foster's assistance, Balderry found employment as a tailor in Colon.

At the age of forty, Felix Cornelius Balderry married sixteen-year-old Ada M. Burns in Constantine. The couple's only child, Frank, was born in Leonidas two years later. Felix died of tuberculosis in 1895 and was buried in the Leonidas Cemetery, where his grave is maintained by the local military.

WHY IS IT CALLED LEONIDAS?

Was this little Michigan township named for Leonidas, the Greek warrior king? Was it named for Leonidas Kestekides's scrumptious chocolates? The story of how Leonidas got its name is a convoluted one, but it goes something like this.

What we know as Leonidas Township didn't exist when the Michigan Territory organized St. Joseph County. From 1829 to 1833, Leonidas was part of Flowerfield Township. From 1833 to 1836, Leonidas was part of Colon Township. But even then, it still wasn't really Leonidas. At a meeting called to decide the name of the township, Levi Watkins suggested Fort Pleasant to express the beauty of the local scenery.

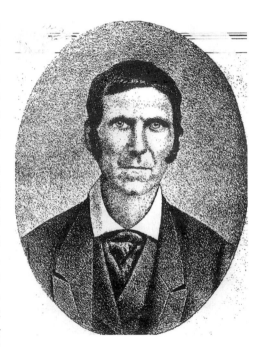

Levi Watkins lobbied for another name for Leonidas. *Courtesy of the St. Joseph County Historical Society.*

And why not? The Leonidas post office was already named Fort Pleasant and remained so until 1850. But a majority of townsfolk opposed the name Leonidas and voted for a shorter name, Leoni. At the same time, townsfolk in Jackson County decided to create their own Leonidas Township. The Leoni petition and the Leonidas petitions reached the

legislature at the same time, and through a clerical error, the names were switched. Hence, Leonidas in Jackson County became known as Leoni, and St. Joseph County's Fort Pleasant/Leoni became known as Leonidas.

RAWSON'S KING MILL

High school seniors and brides who pose for photos in front of the waterfall, kayakers who portage the short distance over the dam and kids who dip

Eston Manard Rawson and Lydia Finch Rawson lovingly restored King Mill in Leonidas, Michigan, now a popular wedding venue. *Photo by the author.*

their fishing poles into Nottawa Creek certainly appreciate the beauty of the property in Leonidas owned by the St. Joseph County Parks and Recreation Department, but they may not know its history.

So let's work our way backward through the history of Rawson's King Mill, the last mill standing in St. Joseph County.

In 1991, a generous local couple, Eston Manard Rawson and Lydia Finch Rawson, gave to the St. Joseph County Parks and Recreations Department the former King Four Mill and four-acre garden, complete with waterfalls and two islands. Mr. and Mrs. Rawson purchased the property in 1967 and spent the rest of their lives restoring the mill, planting gardens and building rugged rock walls. Because they didn't have a need to make their own flour, Mr. Rawson adapted the water-powered turbines to provide electricity in their living quarters in the mill building.

For nearly one hundred years prior to Mr. and Mrs. Rawson's arrival, the mill actively produced flour for the King Milling Company.

In the years since it received the property, the St. Joseph Parks and Recreation Department has done much to make the property available and accessible to the public.

LOCKPORT TOWNSHIP

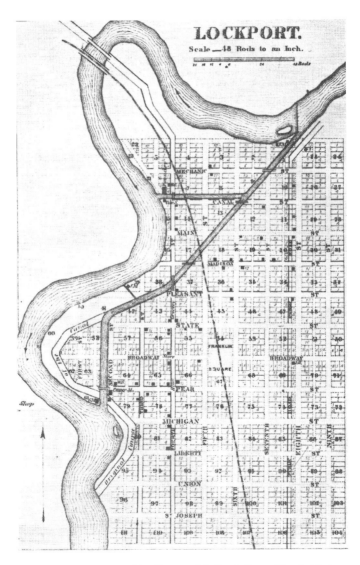

Map of Lockport Township. *Courtesy of St. Joseph County Historical Society.*

BELIEVE IT OR NOT!

In 1918, Leroy Robert Ripley published the first of many cartoons featuring oddities. As popularity of his *Believe It or Not!* cartoons grew, he dropped his first name, shed an underage wife and traveled the world in search of exotic people and things. In South America, he bought human shrunken heads, amassing the largest collection in the world; in India, he interviewed a man who slept on a bed of nails every night for eighteen years; in Italy, he toured the ruins of Pompeii. He traveled to 201 countries but often relied on his 80 million readers to alert him to oddities.

Twelve million people from Hollywood to Thailand have paid a hefty sum to purchase tickets to glimpse weirdness in Ripley's museums, but you can see a genuine *Ripley's Believe It or Not!* oddity here in St. Joseph County, and it won't cost you anything.

Just go to Lockport Township, where the Culbertson Cemetery is recognized by Ripley's as "the cemetery in the middle of the road." This tiny, oddly shaped cemetery, surrounded by Covered Bridge Road (County Road 133) and Leland Road, contains the graves of descendants of the Culbertson family who emigrated from Ireland in 1801. They farmed the land on which the Culbertson Cemetery sits from 1835 to 1983. According to the will of Carroll Culbertson, who passed away in Three Rivers at the age of eighty-nine, only members of the Culbertson family may be buried in the cemetery, which is maintained by Lockport Township.

THE KINGDOM EAST OF THE DEAD SEA

Christopher Shinnaman planned and platted the Village of Moab in July 1830. To get the ball rolling, Abraham and Molly Rickert deeded 138 acres of land to Mr. Shinnaman. When Centreville was named by Governor Porter on November 22, 1831, as the St. Joseph County seat, the Village of Moab was on the verge of becoming an industrial center. But that never happened. All that remains of the Village of Moab is a boulder placed by the Abiel Fellows Chapter of the National Society of the Daughters of the American Revolution on October 25, 1925. If you are ever waiting at the stop sign at the corner of Constantine and Broadway in Three Rivers, you can see the giant boulder and plaque.

THE LAWYER AND THE DEER

Michigan lawyer Columbia Lancaster enjoyed a long and distinguished career in government that lasted until he died in 1893 at the age of ninety, spanning as far west as Oregon, where he served on the Supreme Court, and to Washington, as the territory's first delegate to the U.S. House of Representatives. In the Northwest, he served as a trustee for the University of Washington, and in the private sector, Columbia Lancaster enjoyed life as a lumber baron and developed Pacific railroads.

But his life as a Michigan lawyer was far less celebrated. Shortly after admission to the bar, he established a law practice in Centreville. So few were his clients that, in the early 1830s, he supplemented his income as a teacher for one term and as a deer hunter, bagging in a single year one deer per day.

The impoverished lawyer presided over a Lockport Township meeting convened in a tavern, where officers dealt with issues such as the bounty paid for scalping Lockport wolves and an ordinance to prohibit rams and stallions from running amok.

He built one of the first houses in Centreville on a lot given to him by a client in lieu of cash. Described as "not much of a house, and only served as a shelter for him while out on his frequent hunting expeditions. It was made of rough logs, the site of the village being originally heavy oak openings, and had neither door, window, nor floor," graced with "many a fine pair of antlers."

Finally, with the aid of family friend Governor Cass, Columbia Lancaster was appointed district attorney and, in 1837, was elected to a term in the Michigan Territorial Legislature. But in 1841, Lancaster and his wife left Michigan for the Northwest.

DIRTY DEEDS

It was a dark and stormy night. No, wait, it really was a dark and stormy night on the evening of June 28, 1872, when the kidnappers reached their final destination in Lockport, the hillside home of Joseph Demore, located near the intersection of what are now M-131 and M-86. The men stopped just long enough to bury their hostage in a shallow, muddy hole, where he remained until September 6, 1872, when ransom was paid.

That evening, Officer Winslow H. Hatch took his revolver for protection and a lantern for illumination to a predetermined location in Lockport Township, where a mysterious emissary, barking orders along the way, led him to a second location. When they reached Joseph Demore's hilly property, the search party stopped to exhume the kidnapped hostage, described by Sue Silliman as "badly eaten by grubs."

The subsequent capture of the kidnappers and payment of ransom should signal conclusion of this narrative—but this is not the end. Our story ends several years later, with justices of the United States Supreme Court scolding officials of St. Joseph County.

But let's begin this story at the beginning.

In the summer of 1872, a team of two brothers from Three Rivers, along with a Chicago gangster and various other nefarious characters, hatched a plan to halt commerce in St. Joseph County by stealing thousands of county records. With the deeds missing, no one in the county could buy or sell real estate because ownership of property could not be verified.

Their carefully constructed modus operandi to steal the county records and exhort $5,000 from St. Joseph County officials for their safe return seemed flawless and met with some success.

The thieves broke into the office of the register of deeds in Centreville and, unnoticed, drove away with "deeds one to twenty-two and fifty-one. Mortgages—volumes one to ten, [and] ten others taken in a haphazard way, army records, soldiers discharges, insurance policies, a thousand or more recorded papers."

Upon discovery of the crime early the next morning, the sheriff followed a muddy trail of ruts caused by the perpetrators' wagon but lost all traces after crossing the St. Joseph River.

For weeks, the sheriff's staff flooded the county with handbills offering a reward for the return of the books or apprehension of the criminals.

But on August 15, 1872, the sheriff received a ransom note demanding $5,000 from the county. The Board of Supervisors approved only $3,000. The ransom note stipulated that the Chicago law firm of Eldridge & Tourtellotte would take possession of the money, so on September 1, 1872, the sheriff boarded a train for Chicago, and a few days later, county treasurer James Hill negotiated an agreement to pay Eldridge & Tourtellotte the sum of $3,500.

And on September 6, 1872, Officer Winslow Hatch dug up the county records from their muddy grave. When he notified Sheriff Pierce that the records were damaged, Pierce hopped on an early morning train to

Chicago, and as soon as the doors to the law office opened, he demanded immediate return of the county's money. No deal, said the lawyers.

Suspects in the kidnapping were brought to Centreville. The Fonda brothers were arrested in Three Rivers; John was discharged, but

Why would anyone hold the deeds of St. Joseph County, Michigan, for ransom?
Courtesy of the St. Joseph County Historical Society.

brother Anthony, who happened to be a private detective, as well as a suspected kidnapper, was ordered to post $2,000 bail or stay in jail until commencement of his trial the following year. A third suspect, Charles C. Hildebrand of Indianapolis, was released.

Still angry over the deal made with the Chicago law firm, county treasurer James Hill brought a lawsuit against the firm to recover the $3,500 ransom money, plus another $3,500 to cover the cost of having the records recopied (whether L.A. DesVoignes of Mendon, the man who recopied the records, actually received $3,500 is unknown), plus $1,000 for attorneys' fees and $1,500 for miscellaneous expenses.

The lawsuit worked its way through the American legal system until it reached the United States Supreme Court. The story of the kidnapped deeds ends in 1878, when, in the case of *Eldridge v. Hill*, the United States Supreme Court chided Mr. Hill, the St. Joseph County treasurer, for suing the attorneys, who "acted in good faith." Not convinced that the books were badly damaged, the court acknowledged "some fading of the ink" and that a leaf was missing from one book "and three from another" and ruled against St. Joseph County.

Prior to 1974, the records were stored at the Three Rivers Savings & Loan and later moved to the First National Bank in Three Rivers. After a fire in the First National Bank, the records were transferred to Citizens Bank in Sturgis. In 1974, the county records preserved on microfilm were moved to a ten-story vault in a gypsum mine in Grand Rapids.

The badly damaged deeds, muddied and eaten by insects, are now stored in the St. Joseph County Historical Society Museum for all to see.

ESCHOL

Sue Silliman wrote, "For a time the little village flourished and was a rival of the newly founded town of Three Rivers." The Abiel Fellows Chapter of the Daughters of the American Revolution deemed the "little village" important, memorialized with a monument, one of only a few erected in St. Joseph County.

The Village of Eschol showed great promise: situated near the banks of the Prairie River (known at the time as Hog Creek) and St. Joseph River, surveyed by John S. Barry, platted by Judge Charles B. Fitch and Judge Asa Wetherbee, streets laid out and appropriate names chosen—Nottawa, Water,

This page: The St. Joseph County Courthouse in Centreville has undergone several transformations. *Courtesy of the St. Joseph County Historical Society*

Short, Cass, Fayette and LaGrange running east and west and St. Joseph, Pigeon and Lake running north and south. Perfect. By 1832, the town was open for business.

Charles Fitch and Asa Wetherbee formed a partnership in a combination sawmill and gristmill powered by the waters of the Prairie River, dammed near the St. Joseph River. Mr. R.M. Welch carded wool for ladies to spin. Black Hawk War veteran Benjamin King cobbled shoes in the tiny room he shared with his bride before moving to Three Rivers. A blacksmith shoed horses, and a general store sold everything the people of Eschol needed.

Eschol thrived, but seven years later, it was gone. In 1840, the dam built by Judge Fitch and Judge Wetherbee burst, flooding the town. Concerned parties entered into litigation that lasted for years, and the dam was never rebuilt.

The only evidence that the town existed is the market erected by the Abiel Fellows Chapter of the Daughters of the American Revolution on October 25, 1925, on Constantine Road, north of Shorewood Drive.

DID YOU FORGET SOMETHING?

After Governor Porter declared Centreville the county seat in 1831, the Board of Supervisors met in White Pigeon to authorize the building of a jail—a two-story, wooden structure later burned to the ground by a prisoner—and continued to hold trials in White Pigeon. In 1833, Governor Porter reminded the folks of St. Joseph County that "the courts [are] to be held at the courthouse at the county seat," so the Village of Centreville got busy designating a room on the upper story of Thomas Langley's store at Main and Clark for the courthouse. It wasn't until 1842 that the county built a proper building for the courthouse—a wooden structure that served its purpose for nearly sixty years.

MENDON TOWNSHIP

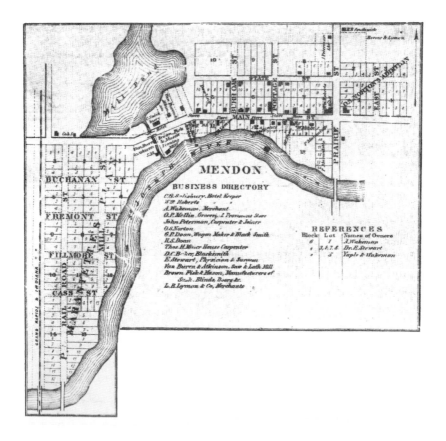

Map of Mendon. *Courtesy of the St. Joseph County Historical Society.*

LIGHTING THE WAY

T.M. Sherriff, editor of *The St. Joseph County Directory, Containing Alphabetically Arranged Directories of Adult Residents of All the Villages and Complete List of Property Owners, the Townships, with Number of Acres, Post Office Address, Section and the Valuations 1880*, admitted to "some slight errors" but maintained "it to be as free from these as any like work ever bought out in our state." A monumental undertaking in a time before computers, he is to be congratulated for his effort.

Unfortunately, this entry short-changes a Mendon man both by its brevity and by the misspelling of his surname: "Wooley Leonidas G., electrician and inventor; res Nottawa St bet Main and State."

Actually, Mendon resident Leonidas Gorham Woolley, spelled with two l's, who lived on Nottawa Street between Main and State, saved lives as the inventor of the first electric highlight for railroad locomotives. Prior to 1881, some railroads ran from dawn to dusk, closing down at night because the lack of a dependable light source posed a safety risk for passengers and pedestrians.

Perfecting the headlight was no easy task, however, as the violent motion of a moving train could render a headlight useless. But in 1881, Mr. Woolley received a patent for his invention.

The U.S. Patent Office continued to award him patents for his inventions, including two for vaporizers, the "vaporizer for gas engines" and the "disinfectant vaporizer"; the "holder for incandescent electric lamps"; the "combined syringe and electrical apparatus"; and an "electric music-box."

Though not as famous or prolific as Thomas Edison, who held more than one thousand patents, nevertheless, Leonidas G. Woolley contributed to the advancement of electrical science.

THE GOLD DIGGER

Alche Van Doren Voorhees, a widow who lived near Syracuse, New York, faced a dilemma soon after her marriage to Jacob Springstead, a suitor who offered her and her son the opportunity to start a new life in Mendon, Michigan.

Her strong-minded son had other ideas. Abram had been on his own since the age of six, when his father died and his mother sent him away to live with

Abram Voorhees left Mendon for California, where he searched for gold.
Courtesy of the St. Joseph County Historical Society.

relatives. By age twelve, he had left school and went to work on a neighbor's farm. It was a good job that included meals, a place to sleep, clothing and time off to attend school if he wished to. He liked farming and saw a secure future with a farmer who promised him a fancy suit and $100 when he turned twenty-one.

Abram's new stepfather upped the ante: unspecified clothing and $100 payable upon his eighteenth birthday, a full three years earlier than the farmer's offer.

It was a no-brainer for Abram. He moved to Mendon with his mother and stepfather.

When Abram turned eighteen, Jacob Springstead gave his stepson the birthday present he promised, plus a little extra: "[O]ne pair of oxen worth $50, one pair of three-year-old steers worth $35, three yearling heifers worth $15, and in addition made him a present of a two-year-old heifer besides."

Abram immediately built sheds for his animals (his birthday was March 23, and we can assume the animals needed immediate shelter), and the following spring he planted ten acres of corn on land he rented from a neighbor. His industrious nature paid off. By the time he turned twenty-one, Abram Voorhees was a married man who owned hundreds of acres of land in Mendon.

Whether he left Mendon because of ill health or for other reasons is undetermined, but he traveled to California, where he searched for gold. After a year, he returned to Mendon with a small fortune and a desire to hold public office. The citizens of Mendon elected him treasurer, then supervisor of the township and finally justice of the peace. Throughout his life, Abram Voorhees abstained from drinking alcohol, which he believed others should do as well, but not all voters agreed with him, and occasionally whiskey drinkers defeated him.

And once again, restless Abram Voorhees joined a wagon train headed for California but got only as far as Montana, where well-laid plans fell apart.

Abram Voorhees returned to Mendon again and spent the rest of his life there running for office and raising horses.

St. Patrick and an Ostrich Named Gaucho

An elderly, white-haired lady instructed her neighbors to kill all her animals immediately after her death. Whether the people of Mendon followed through with the massacre is unknown; however, her pet dog lies beside her in the Mendon Township Cemetery.

This was an unusual request made by an unusual woman, Emma Peek.

A diary written when Emma was around ten years old describes an idyllic life for Mendon girls. As the town's young men marched off to fight the Civil War, girls spent time at home practicing the domestic arts. There were stockings to mend, mittens to knit and the latest fashions to sew. Like today's fashionistas eager for celebrity-inspired clothes, in the 1860s Mendon girls had to have a Garibaldi—a puffy, long-sleeved blouse named for Italian revolutionary Giuseppe Garibaldi. No doubt, Mendon girls browsed Main

Street shops for fabric to quickly sew a copy of this must-have fashion item. Cool autumn mornings were spent in nearby orchards picking apples for pies sold at church bake sales.

But Miss Emma Peek wasn't interested in sewing Garibaldis or pie baking; she preferred to train horses on the family farm with her younger sister, Myrtie. Never a fan of women riding with legs astride their horses, she always rode sidesaddle, her long skirt demurely covering her ankles.

As a young woman, she competed in horseraces held by the Mendon Driving Park Association on a racetrack built in a field south of the Voorhees family home, complete with a grandstand for spectators, a judges' stand, a ticket office on Nottawa Street and a stable for visiting horses. The racehorse owners stayed at the TK Hotel.

It was at the Mendon racetrack that she issued a challenge "open to the world." She would jump five times with her Dublin-born horse, St. Patrick, holder of the world's record for jumping: seven feet, ten and a quarter inches. Any horse surpassing these five jumps would win for its owner a prize of $1,000, deposited in the First State Savings Bank in Three Rivers.

In later years, Emma hitched Gaucho, her trained ostrich, to a pony cart and rode into town to shop or visit neighbors. The usually well-behaved

Emma Peek of Mendon became the horsewoman known worldwide as Madam Marantette. *Courtesy of the St. Joseph County Historical Society.*

bird went berserk one morning and attacked Emma's cousin Orla Richards. The bird knocked cousin Orla to the ground and jumped on top of the injured man. It was not until Bud, a man who worked for Emma, grabbed the ostrich by the neck that Gaucho stopped his rampage.

At the age of twenty-four, she married Charles Marantette, a local bartender two years her junior. The marriage didn't last long, but she kept the surname Marantette throughout her life, even after marrying her second husband, David H. Harris, a circus performer.

Dropping her first name and adding the sobriquet Madam, never spelled with the letter "e," Emma Peek of Mendon became known around the world as Madam Marantette.

MOTTVILLE TOWNSHIP

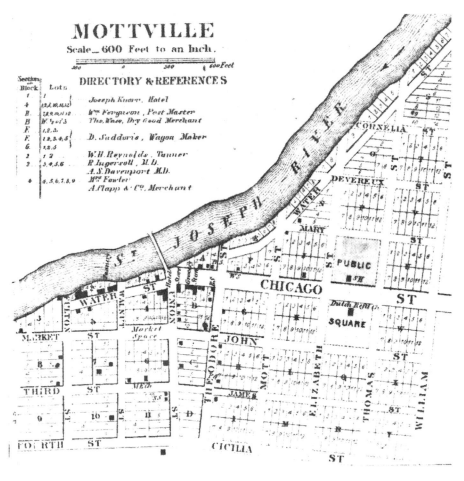

Map of Mottville. *Courtesy of the St. Joseph County Historical Society.*

THE BEST OF TIMES AND THE WORST OF TIMES

At age eighty-one, Abner Murray Beardsley reminisced about his life in New York State and St. Joseph County, where, as a teenager, he settled with his parents and siblings.

Here is what he said about life in the Empire State:

> *I see a boy among the health giving hills and evergreen piney woods of New York…the healthy blooming hills of Seneca Lake, N.Y.*
> *I attended the celebration of the completion of the Erie canal, the first public improvement of any consequence in the western world.*

Contrast those sweet memories with the harsh reality of Mottville and Constantine:

> *Later* [I was] *a young and vigorous man brought low by the malaria of the St. Joe valley, battling with hardships, witnessing the sufferings of friends and neighbors as they became victims of malarial fever, black vomit and death. The ponds and lakes that then held pestilence in their sluggish depths and which sent forth poisons, causing sickness and death.*

Beardsley often repeated an apocryphal recollection of healthcare administered by a Mottville resident as follows:

> *At Mottville I saw a man by the name of Quimby who had a hermitage on the islands just below the city limits. He was about forty years old, of muscular build and dark, swarthy complexion, and something of a pugilist besides….I learned* [he] *had been employed some time before as a nurse to a young lawyer…who had the chills and fever scourge at this city. He was such a troublesome patient no one could do anything with him. Quimby said as a last resort he would try the meat ax remedy on his patient.*
> *He went out and found an ax, brought it into the room, threw it on the floor with a vengeance gave his patient a savage look.*
> *The fever subsided immediately and in a few days the patient was able to be out on the streets.*

Dr. Ira Packard of Sturgis. *Courtesy of the St. Joseph County Historical Society.*

The lawyer was cured, but disease continued to roar through the area:

We sent to Mottville for Dr. Sanger. When he came he was seemingly worse off than the patient. He dosed out some calomel [a toxic substance that caused the death of author Louisa May Alcott]*, castor oil, and fever powders, and was barely able to ride home. The castor oil was old, and the stomach wouldn't have it. The stuff would go out between our teeth in spite of us. We were all very sorry that we were fated pioneers.*

Dr. Ira F. Packard did his best to treat his patients, but sometimes helped arrived too late, or not at all, as was the misfortune of a family living nearby:

In the night the child died. They fired alarm guns for assistance, but no assistance came, as there was none able to be out nights and very few in day time. Three of us, then boys, were enlisted to conduct their funeral for them.

Later that year, Beardsley left St. Joseph County and returned to Seneca Lake, New York.

The People of Puddleford

For more than thirty years, the *Knickerbocker* magazine published only the works of America's finest authors: James Fenimore Cooper, Washington Irving and Simon Oakleaf, among others. We remember James Fenimore Cooper for his historical novel *The Last of the Mohicans* and Washington Irving for two short stories: "The Legend of Sleepy Hollow" and "Rip Van Winkle."

But who the heck was Simon Oakleaf? Using the pen name Simon Oakleaf, Constantine resident H.H. Riley wrote a series of humorous essays about the people of Puddleford, Michigan, for the *Knickerbocker* magazine, later published in book format, which he begins as follows:

Puddleford was well enough as a township of land, and beautiful was its scenery. It was spotted with bright, clear lakes, reflecting the trees that stooped over them; and straight through its centre flowed a majestic river, guarded by hills on either side. The village of Puddleford (there was a village of Puddleford, too) stood huddled in a gorge that opened up from the river; and through it, day and night, a little brook ran tinkling along, making music around the "settlement."

This, precious reader, is a skeleton view of Puddleford, as it existed when I first knew it. Just out of this village, sometime during the last ten years, I took possession of a large tract of land, called "Burr-oak Opening," that is, a wide, sweeping plain, thinly clad with burr-oaks. Few sights in nature are more beautiful. The eye roams over these parks unobstructed by undergrowth, the trees above, and the sleeping shadows on the grass below.

He introduces us to some local Puddlefordians, as he called them: a local tavern owner, a judge and a preacher. But Mr. Riley didn't always portray his neighbors favorably. He depicted them as drunkards, functionally illiterate and dishonest.

New Yorkers who read *Knickerbocker* magazine regaled in tales of these country bumpkins. The people of Mottville, as they correctly deduced, stood for the fictitious Puddleford.

Author H.H. Riley enjoyed a long career as a lawyer and politician. He was prosecuting attorney for St. Joseph County, circuit court judge and elected as a Michigan state senator twice. He died in 1888 and was buried in the Constantine Township Cemetery.

CHIEF SHAVEHEAD

The leader of a small band of Potawatomi gained notoriety in Mottville for his physical appearance—an imposing body topped by a shaved head—and his business acumen. Historians dispute many details of the chief's life; some say he fought in the War of 1812 while others dismiss these claims as a total fabrication.

But two facts are certain: he earned the name "Chief Shavehead" because he shaved the front portion of his head, and he provided a service to settlers, appreciated by most but not all.

Surmising that traffic along the banks of the St. Joseph River would increase as the Chicago Indian Trail became the Old Chicago Road and noting a gristmill on the opposite side of the river, he seized the opportunity to establish a ferry. There was no bridge in Mottville at the time, so he and members of his tribe built a raft and lay rope across the river—simple but effective. To ensure that travelers paid for the service, Chief Shavehead personally collected tolls. The fee was small, and most settlers paid even if they crossed the river without using the ferry, either by driving their wagons or wading through the water.

Asahel Savery, a resident of St. Joseph County, took issue with paying the toll. One day, he didn't see the chief on duty, so he crossed the river without paying the toll. But on his return, Chief Shavehead arrived and demanded payment. An outraged Savery viciously beat the chief with a whip, tore his gun from him and threw it in the river.

Humiliated and injured, the chief retreated into the woods. Whether he was murdered by Savery or simply didn't return to Mottville is a matter of dispute, but he was never seen again.

NOTTAWA TOWNSHIP

OPORTO

By Thomas Talbot

The proposed village was started by John W. Talbot of Centreville and George Talbot of Marcellus, New York. Located on the north shore of Sand Lake in Nottawa Township, Oporto was laid out in anticipation of the GR&I Railroad.

Workmen were summoned for New York, and a store and post office were built.

Right of ways were obtained for an inlet from the Prairie River on the south end of the lake and a millrace leading out of the northwest end back into the river.

In 1837, Thomas Langley bought half of the unsold lots of Oporto from George Talbot and, together with the Whitneys, made up some of the fifteen-plus people who had a vested interest in the new town.

But the Village of Oporto was not to be. As the plans for the railroad were put on hold, by 1840–41, Oporto had slipped into history.

A hand-drawn map of the Village of Operto is on loan to the St. Joseph County Historical Society.

CAN YOU RUN AS FAST AS A HORSE?

Like many early settlers, thirty-four-year-old Joseph Butler triumphed over adversity before settling in Nottawa Township. At age sixteen, the lad from Canandaigua, New York, left his home to serve his country as a volunteer soldier in the War of 1812 and matched wits against British soldiers at the Battle of Black Rock.

In Nottawa Township, he again faced an adversary, and this time it was an American. As sometimes happened in St. Joseph County, two men simultaneously coveted the same piece of property; in this case, the land in question was the east half of the northwest quarter of section 10, which Mr. Butler purchased in 1830.

In such a dilemma, local law ruled that the first person to file an application in the land office in Monroe, a journey of more than one hundred miles, would be the new owner. Tipped off by a neighbor that Butler's adversary had departed on horseback for the land office earlier that morning, Joseph Butler ran to Monroe.

In the *History of St. Joseph County*, the story is told this way:

> *Butler went to his house, provided himself with moccasins for the journey, and on foot started on the race for his land. He could track the horseman and followed as best he could, and between Tecumseh and Monroe, while the horse and man were eating, he passed them, and without loss of time entered Monroe, found the land register, made his application for his land, stepped to the receiver's office, paid his money, got his duplicate for his land, and just as he crossed the Raisin bridge on his return, met his horseman friend going into town. He took it more leisurely home. Soon after, he built on that land, which was ever after his home until his death.*

CARRIE NATION

The St. Joseph County Fairgrounds in Centreville hosts everything from 4-H exhibits, to circuses, to famous performers like Reba McEntire. A century before Ms. McEntire sang her heart out in Nottawa Township, crowds lined up to see a six-foot-tall, twice-divorced, often-arrested, hatchet-wielding woman. In anticipation of this lady's arrival, special trains were added to

Carrie Nation, later known as Carry A. Nation, sold souvenir hatchets at the St. Joseph County Fairgrounds in Centreville. *Courtesy of the Library of Congress.*

the Centreville railroad schedule to accommodate people from as far away as Union City.

For years, Carrie Nation (she changed her name to "Carry A. Nation" shortly after leaving Centreville) traveled around America alerting its citizens to the evils of alcohol consumption. She spoke in churches. She shamed people on street corners. She visited saloons, and with a supply of rocks, she smashed everything she saw until local law enforcement put her in jail. In Topeka, Kansas, she swung a hatchet around the heads of patrons enjoying their refreshing, cold beers. A local judge ruled she was insane, but she avoided confinement in the local asylum by revealing the judge's interest in obscene artwork.

By the time she reached Centreville, Carrie Nation and her hatchet were so famous that she sold audience members autographed photos of herself and small hatchet replicas.

The following is the text of a flyer advertising her 1903 visit to the fairgrounds:

> *The most unique character in the country today and probably the most widely talked about woman that has ever stood before an audience, is Carrie Nation, the strenuous Kansas lady who will speak at the St. Joseph County Fair: Centreville, Mich., Thursday, October 8, 1903. The joint-smasher is an able and interesting talker and expresses her views in a manner as original and interesting as she is herself. Those who are interested in the cause of temperance, and those who are not, look forward with interest to hearing this famous and energetic woman. Saloonists, their bondsmen and W.C.T. [Woman's Christian Temperance] Unions all over the country are invited to attend, as she may be depended upon to handle her subject without gloves.*

Despite her theatrics, Carrie Nation influenced Congress to pass the Eighteenth Amendment prohibiting the sale or manufacture of alcohol, repealed in 1933, as well as the Nineteenth Amendment granting women the right to vote. Carrie Nation died in 1911 and did not live to see the passage of these amendments.

DR. DENTON

In the classic movie *The Christmas Story*, Ralphie Parker wanted only one gift from Santa: "an official Red Ryder Carbine Action 200-shot Range

Model air rifle with a compass in the stock and this thing which tells time." His mother and teacher warned him against the dangers of such a gift: "You'll shoot your eye out." But on Christmas morning, a surprised Ralphie gently removed bright red wrapping paper from a long box revealing the coveted air rifle. Having suffered the humiliation of wearing Aunt Clara's gift— footed pajamas—you can't help but feel the kid deserved it.

Ralphie's mother appreciated Aunt Clara's thoughtfulness of the homemade gift, but his father says the boy looked like a "deranged Easter Bunny," "a pink nightmare."

Generations of boys and girls like Ralphie Parker, who were forced to wear footed pajamas with a drop seat for nighttime visits to the bathroom, can trace the source of their humiliation, and it is not Aunt Clara. It is a Centreville man named Whitley Denton.

Mr. Denton, the well-meaning manager of the Michigan Central Woolen Company in Centreville, started it all when he solved the problem of keeping the toes of

A local Centreville girl was chosen to model Dr. Denton's famous footed pajamas. *Courtesy of the St. Joseph County Historical Society.*

children warm on cold Michigan winter nights. With scraps of woolen fabric "borrowed" from the factory, he designed a one-piece, blanket-like sleeper. Initially, Whitley Denton, or more likely his wife, Lillian (he was, after all, a manager, not a seamstress), sewed sleeper garments for Centreville kids. Later, the Dr. Denton Sleeping Garment Mills on Dean Street manufactured thousands of "Dr. Denton's," sold to stores around the world.

Above: Dr. Denton of Centreville wasn't a real doctor. He thought the name Dr. Denton gave credibility to the health claims of his product. *Courtesy of the St. Joseph County Historical Society.*

Left: The Dr. Denton Sleeping Garment Mills on Dean Street in Centreville provided employment to the community for several decades. *Courtesy of the St. Joseph County Historical Society.*

Marketing the product under the name Dr. Denton, rather than Mr. Denton, implied that a medical doctor endorsed the pajamas, and in fact, magazine advertisements supported this illusion with claims that the garment was "specially devised to give most healthful sleep" and could "prevent colds which often lead to pneumonia and other dangerous ailments."

Dr. Denton and his invention provided employment to generations of Centreville workers. The factory finally closed in 1988.

O PIONEERS!

The Pioneer Society of St. Joseph County was established in Centreville on October 16, 1873.

A group of St. Joseph County citizens met in Centreville to establish the Pioneer Society of St. Joseph County soon after the Michigan legislature enacted a law creating the Pioneer Society of the State of Michigan "for the purpose of collecting and preserving historical, biographical or other information, in relation to the State or Michigan, or any portion thereof."

On October 16, 1873, the group laid out the society's rules: membership

John Lomison was a founding member of the Pioneer Society of St. Joseph County. *Courtesy of the St. Joseph County Historical Society.*

was limited to only those settlers who arrived in the county prior to 1840 (making it an exclusive club of only 150 members), Judge James E. Johnson and Judge William Cross would draft the constitution and the honor of president would be bestowed on the oldest settler living in the county, eighty-eight-year-old Asahel Savery, who settled in White Pigeon in 1828.

For several decades, the St. Joseph pioneers held annual meetings in Centreville and contributed their reminiscences to forty volumes of *The Report of the Pioneer Society of the State of Michigan*, which Michigan State University librarian Michael Unsworth cites as "a critical source in researching the Wolverine State's early history."

Copies of the reports by the original pioneers are available at the St. Joseph County Historical Society.

William Hazzard was a founding member of the Pioneer Society of St. Joseph County. *Courtesy of the St. Joseph County Historical Society.*

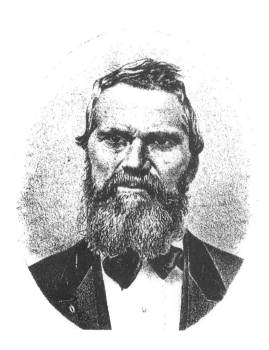

James Johnson was a founding member of the Pioneer Society of St. Joseph County. *Courtesy of the St. Joseph County Historical Society.*

PARK TOWNSHIP

PROPHET OF DESTINY

On January 12, 1861, the Seventh-day Adventist Church in Parkville welcomed visitors to the church's official dedication ceremony, which included, in a lineup of speakers, local church leaders and nationally recognized guests.

There exists no transcript of Brother Waggoner's sermon, nor the dedicatory prayer given by Brother Arthur White. No doubt, the congregation listened respectfully, perhaps anticipating refreshments afterward. But when the men finished, Brother White's wife rose from her chair, and what happened next shocked everyone in the church.

The brother's wife, Ellen White, fell into a trance, unconscious of her surroundings and so still that she appeared not to breathe.

Dr. Brown, a local physician in the congregation, examined her, as Rene Noorbergen recalls in his book *Ellen G. White: Prophet of Destiny*:

> *Before he had half completed his examination, he turned deathly pale, and shook like an aspen leaf. Elder White said, "Will the doctor report her condition?" He replied, "She does not breath[e]"; and rapidly made his way to the door. Those at the door who knew of his boasting, said, "Go back and do as you said you would; bring that woman out of the vision." In great agitation he grasped the knob of the door but was not permitted to open it until inquiry was made by those near the*

Ellen White predicted the death of young men from St. Joseph County long before the start of the Civil War. *Courtesy of the Ellen G. White Estate, Inc.*

door, "Doctor what is it?" He replied, "God only knows, let me out of this house."

After twenty minutes, Mrs. White resumed breathing and shared her vision with the remaining congregants.

As John Loughborough writes in his book *The Great Second Advent Movement*:

"There is not a person in this house who has even dreamed of the trouble that is coming upon this land. People are making sport of the secession

ordinance of South Carolina, but I have just been shown that a large number of states are going to join that State, and there will be a most terrible war. In this vision I have seen large armies of both sides gathered on the field of battle. I heard the booming of the cannon, and saw the dead and dying on every hand. Then I saw them rushing up engaged in hand-to hand fighting [bayoneting one another]. *Then I saw the field after battle, all covered with the dead and dying. Then I was carried to prisons, and saw the suffering of those in want, who were wasting away. Then I was taken to the homes of those who had lost husbands, sons, or brothers in the war. I saw their distress and anguish."*

Then looking slowly around the house she shouted, "There are those in this house who will lose sons in the war."

The shocked congregants shuddered at the thought of losing their loved ones to an as yet undeclared war. But as the dead were returned to St. Joseph County, Parkville churchgoers remembered the words uttered by Ellen White four months before the Civil War commenced at the Battle of Fort Sumter.

MOORE PARK STATION

Little, if anything, of the original Village of Moore Park exists.

Moore Park, or Moorepark as it is sometimes called, was named in honor of philanthropist and businessman Edward S. Moore. Mr. Moore began working at the age of ten, engaging in various occupations: tailor, canal builder, store owner. By the time he arrived from Pennsylvania with his wife, Mary, and brother, Burrows, he had the experience and ambition to make a name for himself.

Recognizing the future of railroads at a time when the St. Joseph River served as the county's fastest means of transportation, he joined the St. Joseph Valley Railroad Company as president and lobbied for the completion of a railroad through St. Joseph County.

In the 1850s, he purchased 450 acres of land in Park Township, where he built a home described by reporter Ed Knapp as follows:

A large white two-and-one-half story structure; a magnificent Southern style mansion. The towering front porch entry to the home was beautifully beset with four large rounded white pillars of classic distinction. The

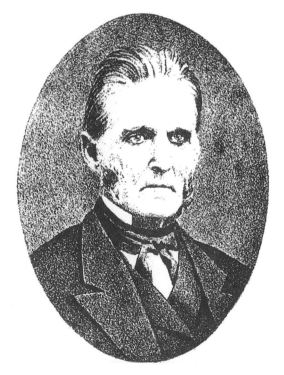

Above: The home of Edward S. Moore in Park Township. *Courtesy of the St. Joseph County Historical Society.*

Left: Edward S. Moore, Park Township's philanthropist and self-made businessman. *Courtesy of the St. Joseph County Historical Society.*

columns reached to the full height to the expansive roof gable, presented a perfect picture of true Southern charm. The generous overall size of the elegantly Old Colonial style mansion, covered a ground area equal to eight regulations size city lots.

Visitors to the Plantation arrived on horseback or in horse-drawn buggies, and after completion of the Moorepark Railroad Station, built a few hundred yards from the house, guests arrived by train. Guests without horses were permitted to select a horse from Mr. Moore's vast stable.

Edward S. Moore died in 1885 and was buried in Riverside Cemetery in Three Rivers. The old train depot named for Mr. Moore was demolished, and the Plantation, a grand house resembling a southern mansion, burned down in 1943, despite the valiant efforts of the local fire department to save the home.

A FAMOUS SCIENTIST

At a time when society discouraged women from attending college, Park Township resident Ruth Hoppin was well on her way to earning a degree in science. She graduated from Oberlin College in 1856 and become one of America's foremost female scientists.

For three years, she taught botany and biology at Smith College in Massachusetts, a private college dedicated to the education of women. Health problems forced her to resign in 1884, and she returned to Michigan to recuperate.

While on a trip to Missouri, she collected specimens for Harvard University's science museum: insects, mollusks, crustaceans, salamanders and fish. It was on such a trip in 1888 that she discovered a species of blind fish (*Amblyopsis rosae*) that eat nutrient-rich bat excrement dropped by bats clinging to the cave walls into water below. The following year, she reported her findings in a scientific journal published by Harvard. Once in danger of becoming extinct, these rare fish and the cave Ruth Hoppin explored are now protected by the State of Missouri and a private land trust.

In her final years, Ruth Hoppin tutored students in Three Rivers. Several years after her death in 1903, the First Ward School was renamed the Ruth Hoppin Elementary School in her honor.

SHERMAN TOWNSHIP

DID MILTON VISIT ST. JOSEPH COUNTY?

Harriet Martineau is perhaps the least-known but most influential sociologist of the nineteenth century. Her writings were so popular that her fans included Queen Victoria, who invited Harriet to her coronation in 1838. Harriet sold more copies of her early works than contemporary Charles Dickens.

In 1834, Harriet Martineau embarked on a two-year tour of the United States, about which she wrote in her book *Society in America*, Volume I. In it, she describes a trip through southern Michigan, where she marveled at the superior taste of wild strawberries.

But she did not enjoy her stay in Sherman Township:

> *We had heard so poor an account of the stagehouse, that we proceeded to another, whose owner has the reputation of treating his guests magnificently, or not at all. He treated us* juste milieu [judicious moderation] *principles. He did what he could for us; and that could not be called magnificent. The house was crowded with emigrants. When, after three hours waiting, we had supper, two full-grown persons were asleep on some blankets in the corner of the room, and as many as fifteen or sixteen children on chairs and on the floor. Our hearts ached for one mother. Her little girl, two years old, had either sprained or broken her arm, and the mother did not know what to do with it. The child shrieked when the arm was touched,*

and wailed mournfully at other times. We found in the morning, however, that she had had some sleep.

I had a little closet, whose door would not shut, and which was too small to give me room to take off the soft feather-bed. The window would not keep open without being propped by the tin water-jug; and though this was done, I could not sleep for the heat.

Harriet Martineau and her traveling companions departed Sherman Township the following morning. On the way to White Pigeon, where she "saw the rising ground where the Indian chief lies buried, whose name has been given to the place," she "passed through a wilderness of flowers: trailing roses, enormous white convolvulus, scarlet lilies, and ground-ivy" and wondered if Milton had "travelled in Michigan before he wrote the garden parts of 'Paradise Lost.'"

CAN YOU NAME THE LAKES IN SHERMAN TOWNSHIP?

If you lived in Sherman Township in 1877, you could count the number of natural lakes on your fingers:

Chapin Lake, named for early settler David Chapin.

Crossman Lake, named for early settler Abel Crossman

Crotch Lake, because it looks like a crotch.

Fish Lake, because of the fish, and if you try hard enough, you may see it is shaped like a misshaped fish.

Johnson's Lake, named for an early settler named Johnson; there's no record of his first name.

Middle Lake, because it lies between Klinger Lake and Thompson's Lake. (It's partially in White Pigeon Township and partially in Sherman Township.)

Thompson's Lake, named for early settler Elijah Thompson, the scene of the unfortunate suicide of Mr. Babe Wells in 1846.

COLONEL BENJAMIN SHERMAN

Benjamin Sherman was not the first settler in Sherman Township. That man was Thomas Cade Sr. A native of England, Mr. Cade arrived in the

township in July 1830. He immediately got to work felling white oak trees and cutting logs for his new house, and when he finished, the house was hailed as "the largest and best log-house ever before erected in St. Joseph County." That autumn, he planted twenty acres of wheat. The soon-to-be prosperous farmer sent for his wife and five children, who joined him in St. Joseph County. The occasion of his daughter's wedding reception in the family home is remembered as the first festivities in the settlement, "when a good old-fashioned dance was indulged in, and the lively tune and the merry song were heard echoing in the neighboring forest."

The family remained in the area, farming the original homestead for generations, warmly welcomed by the growing community.

The growing community, however, did not warmly welcome Colonel Benjamin Sherman, for whom the township is named. Upon examining a choice parcel of land, Colonel Sherman quickly filed paperwork at the U.S. Land Office in Monroe, notwithstanding the fact that a few years earlier, a local doctor had settled on the same property. Although he did nothing illegal, as Calvin Goodrich explained in an article titled "Land Speculation in Pioneer Michigan," "a strong prejudice developed against him when he took possession, affecting his standing as a citizen."

Next, he was sued by George Buck for failure to pay a promissory note worth more than $2,500, and a lien was placed on Sherman's property.

At a town meeting to discuss a probable Indian attack, he sat silently. When he arose to speak, S.C. Coffinberry noted that "every eye rested upon Col. Sherman, and every one sat in breathless silence as he addressed the meeting."

In an oratory style described as self-righteous and moralizing by others who attended the meeting, he said: "I planted the first apple tree west of the meridian line in Michigan, and I have abundant reason to believe that I have as good a knowledge of the disposition of the Nottawa Indians as anyone. I do not believe there is the least danger of their disturbing any of us; I believe the poor cusses are more scared than you are."

The local townsmen were not convinced. "Arm yourself to the teeth, Sherman," said one. "Here, take my horse pistols," said another.

"Pshaw, nonsense," said the colonel impatiently while at the same time grasping a large hickory cane, "I wanted no better protection than this at Mount Morris in York State, in 1829 and have carried it ever since. I have carried it over a thousand miles. It's the true blue. I wouldn't give it for all your footy [insignificant] pistols, in a hand-to-hand scrimmage."

Having nothing further to say, his patience tested by his fellow townsmen, he left the building.

LOADED FOR BEAR

Throughout his life, Lewis Cass undoubtedly enjoyed partaking in sumptuous meals—with Daniel Webster when the two were classmates in the elite Phillips Exeter Academy; as governor when "public dinners and dances were held whenever a suitable opportunity arose…even the opening of a flour mill at Pontiac was commemorated with a public ceremony that included an abundance of food"; and in the White House as secretary of war.

But in 1828, on a journey that took him through St. Joseph County, far less refined fare appeared on his plate. In August 1828, he and fellow travelers, accompanied by eight ponies carrying more than one ton of goods and silver to purchase reserves of the Treaty of Chicago in Niles, stopped in Sherman Township for a bite to eat.

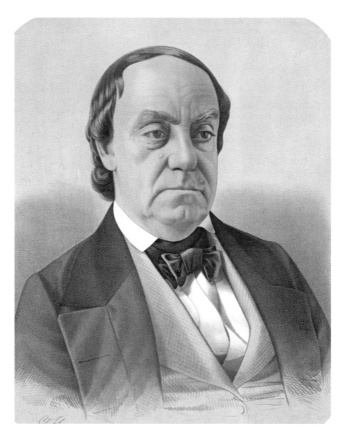

Governor Cass ate a bear in Sherman Township. *Courtesy of the St. Joseph County Historical Society.*

One day earlier, a group of settlers had gone hunting, and with little else to offer Governor Cass, they invited him to a last-minute banquet of bear meat. He accepted their invitation.

The arrangements were soon made, and Bruin was on the spit, from which he was transferred—when cooked to a turn—to the table, and his juicy carcass was highly relished by all. Fun reigned supreme, the Governor forgetting his judicial dignity for a time, joining in the sport as zealously as any of his staff.

Satiated by the greasy meat, the party continued on its way through St. Joseph County.

CITY OF STURGIS

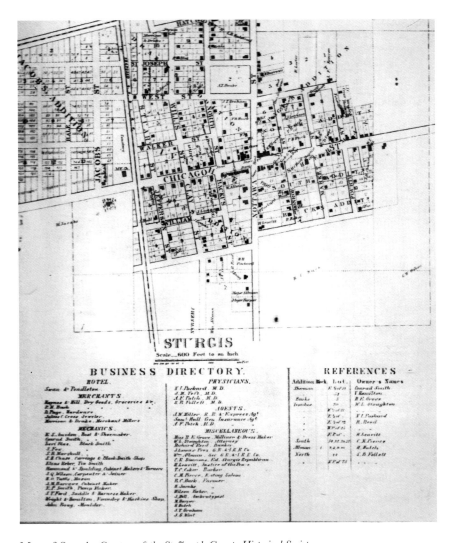

Map of Sturgis. *Courtesy of the St. Joseph County Historical Society.*

CHURNING OUT CHURNS IN STURGIS

For centuries, women and children made butter the same way: pour cream into a container and then, with a stick called a dasher, move the cream up and down and up and down and up and down for hours until the cream solidified. Simple but labor-intensive.

According to the *Encyclopedia of Kitchen History*, in the quest to build a better butter churn, in the nineteenth century alone more than 2,500 inventors filed patents. One of these men was Elliott H. Funk of Sturgis, inventor of the Champion Churner, which used a rotary mechanism in a square-shaped churn.

In 1884, the United States Patent Office issued Patent Number US 305444 A to Mr. Funk for "certain new and useful Improvements in Rotary Churns," putting Elliott H. Funk on the road to becoming a millionaire. He built a two-story factory on Chicago Road, where a team of thirty-five men churned out seven to eight hundred Champion Churns per month for shipment from the Sturgis train station to stores around the country.

Unfortunately, Mr. Funk's attempt to obtain funds for the manufacture of another churn, which he called the "Flora Temple Churn," ended in a lawsuit brought by Mr. Meyers of Iowa, who traded 680 acres of land for an interest in Mr. Funk's patent. But Mr. Funk did not hold a patent for the Flora Temple Churn, and the Supreme Court of Iowa found Elliott H. Funk guilty of defrauding and cheating Mr. Myers.

MUFFLE THAT PIANO!

"This is your last warning," declared Sturgis city officials.

Frustrated by continued disregard of a particular city ordinance, the mayor called on police chief Hettinger to enforce the law of Sturgis. The *Sturgis Journal* reported that Chief Hettinger served notice on the many violators of the law "that the practice will not be tolerated, and that no further warning will be given but arrests will follow."

What crime did these lawbreakers commit? Playing a piano in an ice cream parlor on a Sunday. The good people of Sturgis had had enough of these ice cream–eating, piano-playing culprits and, in 1919, enacted an ordinance to put an end to their crime spree if only Chief Hettinger would enforce the law.

While they were at it, that same year, the citizens of Sturgis threw the book at muffler-less automobile owners, declaring their behavior "a nuisance to the public in general but an annoyance at times aggravating to the extreme."

The editors of the *Sturgis Journal* warned:

> *If you haven't a muffler get one, you'll be ahead because you will not be allowed to operate your car in the city limits, making an unusual amount of noise. A word to the wise ought to be sufficient is the admonition sent out by the city officials.*

And thus, the Village of Sturgis was free from piano-playing ice cream eaters and muffler-less automobiles.

Pigeons and Carbon Paper

The world lost interest in carbon paper with the advent of the word processor in the 1970s, but at one time, Sturgis was a leader in the manufacture of carbon paper–based products.

In 1915, Charles L. Spence received a patent for what he called the "manifolding book," a carbon paper–based invention that made him a very wealthy man. Thanks to the National Carbon Coated Paper Company, believed to be the second-largest company of its kind in the world, traveling salesmen could record orders in little carbon paper booklets—original, duplicate and triplicate copies—with a single stroke of the pen

But Charles L. Spence was not an "all work and no play" type of guy. Mr. Spence went sport fishing for grouper in the Gulf of Mexico with Yankees manager Miller Huggins, an event documented in newspapers around the country. In his spare time, he played golf under the tutelage of his very own private golf pro, Louis Chiapetta.

And Charles L. Spence enjoyed breeding pigeons, in particular pigmy pouter pigeons, the miniature bird noted for inflating its crop, a storage sac around the neck, so that it resembles a balloon. In December 1936, the carbon paper manufacturer brought together members of the American Pigmy Pouter Pigeon Club and the National Pigmy Pouter Pigeon Club in the first ever joint exhibition of pigmy pouter pigeons. The *Sturgis Journal* reported that more than five hundred pigmy pouter pigeons from around the United States were brought together in the Sturgis High School gymnasium for the momentous event.

Charles L. Spence was not the only bird enthusiast in Sturgis. Grocery store owner George Klesert, considered by the *Michigan Democrat* to be "one of the best judges of pigeons and the treatment of the same in the State of Michigan," had so many homing pigeons, carriers, owls and swallows that he held a special sale of his birds in 1897 because he ran out of room to keep the feathered menagerie.

Because That's Where the Money Is

While Willie Sutton was terrifying East Coast bank clerks with a Thompson submachine gun, armed men twice robbed a bank in Sturgis. Perhaps they thought a bank in the quiet village was an easy target, or perhaps they simply heeded the gangster's advice to rob banks "because that's where the money is."

On the morning of September 28, 1926, Wilson Roose, Walter Reick, Earl Hagadorn and Herbert Storms were busily working at the Sturgis National Bank on Chicago Road when four armed bank robbers burst in and headed toward the vault.

Wilson Roose stood in their way and shouted, "I'll die before I let you into that vault!" Then he grabbed a gunman's revolver. A struggle ensued, ending as the robber repeatedly beat Mr. Roose with the butt of the gun.

Wilson Roose was indeed valiant that day, but it was the high-pitched shriek of a local boy who stood by his mother's side that motivated the bank robbers to make a hasty retreat, abandoning their plans to get rich quick.

A child was also present when four men with sawed-off shotguns robbed the Sturgis National Bank on December 17, 1928. The armed robbers ordered clerks Helen Crane and Walter Reick to lie down in the rear of the bank with the customers; however, a little girl refused to follow their directions, explaining to the men that she couldn't stay for the robbery because "I'll be late for school."

The robbers paid no attention to the little girl. They demanded that Mr. Reick open the cabinets that held cash and negotiable bonds. When he couldn't open one of the drawers, an impatient armed gunman beat him severely.

Whether both robberies were committed by the same men is still unknown. Unlike the 1926 robbery, when the men left empty-handed, the 1928 robbery was successful. The men departed with $20,000 in cash and $60,000 in negotiable bounds.

Thankfully, the stunned bank clerks accepted the little girl's deposit to her Christmas savings account before she ran off to join her classmates at school.

THEY GOT THE WRONG MAN

On July 2, 1892, Detective Minthorn from Chicago, who called himself the "Old Sleuth," rounded up three former railroad employees and almost immediately decided that Sturgis resident Henry Grishow had perpetrated the crime of attempting to wreck a Grand Rapids and Indiana freight train.

Sturgis residents were shocked to learn about the arrest of this "upright citizen," who had always "borne a good character." Neighbors swore Mr. Grishow was in bed when the crime occurred, but the Old Sleuth was convinced that Grishow was the culprit and set about getting a confession.

Fully aware of Mr. Grishow's tendency to overindulge, he took the man on a "pub crawl" up and down the streets of Sturgis until Grishow "had to crawl on his hands and knees, and rolled and reeled, and staggered into the house while his wife and three small children looked on."

At trial, the Old Sleuth testified that on the evening of the pub crawl, Mr. Grishow had confessed to the crime. The Circuit Court of St. Joseph County found him guilty, and on January 24, 1893, Grishow was sentenced to the Jackson Prison for a term of ten years.

The good people of Sturgis petitioned for the release of the prisoner, their neighbor whom they regarded as innocent. Michigan governor Pingree agreed, testifying in the official pardon:

> *He was convicted solely on the testimony of Detective Minthorn and this testimony related only to admissions made by Grishow while he was intoxicated, and brought into such condition by the very man who was trying to convict him.*
>
> *The Supreme Court of this State, and the law of the land generally, do not favor this class of testimony, and when we scan the evidence of this detective we can come to no other conclusion than that if Grishow ever made the statements the detective claims him to have made, which we doubt, he was acting with no mind as to what he was saying and could not be held in law accountable for what he did say.*
>
> *Taking into consideration that his wife has supported the family all these years, and that she is now waiting for him in a destitute condition, still believing him to be innocent and all his neighbors and friends believe him to be, we think he should be pardoned at once.*

On August 12, 1900, Henry Grishow received his pardon, having served seven years of a ten-year sentence.

THE FIRST FREE CHURCH IN THE WORLD

The Free Church Park on Chicago Road in Sturgis is the site of the first "free church" in the world. Built in 1858, the second "free church" was in Boston.

In 1858, ministers in Sturgis refused to officiate at the funeral of a poor man because he was not a member of any church. Outraged farmers and locals vowed to build a church where any person or group could hold services. Jonathan G. Wait and Henry Osbon headed up the project. With Dan Chamberlain and Tom Aiken, the men hauled bricks from Fawn River in one day; they carried the bricks on their heads and paraded through Sturgis. Rufus Spaulding and J.M. Barrows built the church, which could hold a crowd of 150.

The church was torn down in the 1920s and the land given to the city. A bronze tablet memorializes the efforts of the kind people of Sturgis who built this extraordinary church.

THE STURGIS FAIR

In the 1890s, the Sturgis Fair rivaled the St. Joseph County Fair. For twenty cents, visitors could bet on horseraces and judge for themselves the quality of livestock, pigs, sheep, cattle, fowl, turkeys, ducks, floral displays, fruits and vegetables, homemade baked goods and handicrafts.

To maintain a sense of propriety, Sturgis police officers were instructed to "guard against the infringement of anyone jumping the fences, hitching horses to trees or driving teams of horses onto the track at the wrong time." Entrants in the Bees and Honey Division were advised that "bees must not be allowed to fly during hours of exhibition."

Railroads offered special low rates during the fair. At the time, seventeen passenger trains brought fair-goers to Sturgis on the Lake Shore and Michigan Southern Railway, the Grand Rapids and Indiana Railway and the Canada and St. Louis Railway.

CITY OF THREE RIVERS

UNITED NATIONS HEADQUARTERS

It may seem farfetched, but the United Nations considered building its headquarters in Three Rivers, Michigan, instead of New York City.

In her book *Capital of the World: The Race to Host the United Nations*, Charlene Mires, professor of history at Rutgers University, explains that New York City was not the UN's first choice because the world's leaders initially rejected New York as "a place where many of the world's diplomats adamantly did not want to be."

In fact, the United Nations considered 248 other cities before settling on New York. Cornelius A. Moylan, mayor of Hartford, Connecticut, touted the city's "high-class industries." Officials of Worcester, Massachusetts, offered "good transportation, hotels, climates and scenery." Hubert H. Humphrey, mayor of Minneapolis (and later vice president of the United States), described Minneapolis as an ideal location halfway between the Atlantic and the Pacific.

So why was Three Rivers suggested as the location of the UN headquarters? It was because of Chet Shafer, a nationally known author living in Three Rivers, who suggested his hometown for its distinction as the International Headquarters of the Guild of Former Pipe Organ Pumpers.

Pipe organ pumpers were those strong little boys who worked diligently without recognition for their service to organists. Seldom seen but certainly heard, the boys pumped air, by hand or with foot pedals,

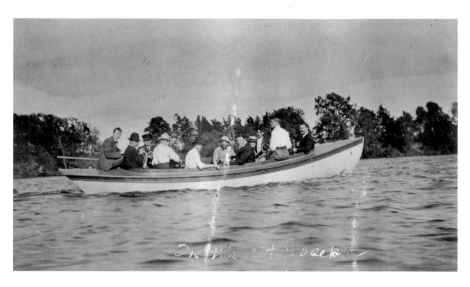

Members of the Three Rivers Band enjoy a boat ride in St. Joseph County. *Courtesy of the St. Joseph County Historical Society.*

into bellows that powered pipe organs in churches, castles and even the Roman Coliseum.

In fact, some of America's outstanding citizens pumped pipes. Perhaps their experience did not directly result in their success and experience pumping pipes was not listed on their resumes, but men like Jimmy Walker, the former mayor of New York City, and Julius Rosenwald, the man who built Sears, Roebuck & Company, spent many hours pumping pipe organs and, as adults, joined the International Guild of Former Pipe Organ Pumpers.

Founded by Chet Shafer in 1926, at its peak membership, the guild numbered four thousand men whose membership cards bore the motto "Pump, for the wind is fleeting." Mr. Shafer conducted the guild's business affairs in Three Rivers, promoted the guild through his nationally syndicated newspaper column and planned conventions in Boston and Paris. It was during the Paris convention that Myron T. Herrick, America's ambassador to France, himself a former pipe organ pumper, established the Paris branch of the International Guild of Former Pipe Organ Pumpers.

Although Three Rivers was considered, the UN search committee kept looking before settling on its current location on Forty-Second Street in New York City. Perhaps the committee was influenced by John D. Rockefeller Jr., who donated the sixteen acres of Manhattan's prime real estate valued at $8.5 million.

STRAWBERRY FIELDS FOREVER

Russel Marion Kellogg of Three Rivers loved strawberries. He really, really, really loved strawberries.

No roses or violets grew in this man's flower beds. He was not a "roses are red, violets are blue" sort of guy, but he did wax poetic about strawberries. In his book *R.M. Kellogg's Great Crops of Strawberries and How to Grow Them*, he wrote:

> *There is certainly nothing more pleasing to the eye than a neat flower bed of any kind, and when we can have a beautiful flower bed loaded down with big red berries we do not stop at pleasing the eye, but here is where the stomach gets satisfaction as well. There are no flowers that make any prettier bed than the strawberry plant with its green foliage, then its load of white bloom with bright yellow center, and lastly the immense donation of blood red berries that make the mouth and eyes water.*

He wrote about the sex life of strawberry plants with the artfulness of a romance novelist, lauding the importance of "congenially mating," and he wrote of the stamina of stamens: "A male plant that has been weakened by pollen exhaustion from any cause should never be used for mating the female." He was not above experimenting with bisexuality, advising a "male or bisexual…strong in potency" to step in immediately after the female flower opens to "insure a perfectly developed berry."

He gave sexist advice on hiring people to pick strawberries:

> *We find that good, careful women make the best pickers; they are much neater about their work than men or boys and are easier handled. Have an understanding with each one, stating just what is expected of her and what she can expect if the rules are not followed.*

He did, however, hire men—men dressed in business suits and hats—to plant his strawberry field in Three Rivers, the largest experimental strawberry farm in the world.

Mr. Kellogg was not the only person in love with his strawberries. Folks grew Kellogg's strawberries across the county. In 1918, a Lansing man wrote a testimonial that he had no experience and little capital, but he grew enough of Kellogg's strawberries to purchase a house, and the profits of Kellogg's Thoroughbred Strawberries grown on one acre of land in Oregon yielded $4,390.50, enough money for its owner, Mr. Z. Chandler, to purchase his house as well.

Strawberry fields in Three Rivers. *Courtesy of the St. Joseph County Historical Society.*

THE BIG BANG

Jim Welper and a few friends were determined to celebrate July 4, 1857, with a big bang from a commemorative cannon. They didn't own a cannon, so the boys MacGuyvered one from bits and pieces salvaged from a water wheel found in an old mill. The night before the big event, they stationed themselves in front of the bank building, where they fired off a few test shots. Things did not go as well as the young men planned. One piece of shrapnel landed on the steps of a hotel, nearly injuring several tourists, and a second piece struck Jim in his thigh near his hip.

Fortunately, Jim's father was a doctor, and he was able to save Jim's leg from amputation. The wound was

> *so close to the hip that it could not be amputated. All that was possible to do for him in those days of scanty surgical skill, was to strap the limb to a support laying him flat on his back for several months, and by keeping the circulation as nearly normal as possible his life was saved, but he became an almost helpless cripple for the balance of his life.*

Not much else is known about Jim Welper. He died in Hillsdale County and was buried in an unmarked grave in the Oak Grove Cemetery in 1870.

THE MENTHOL INHALER

Henry DePuy Cushman could not have chosen a better place than Three Rivers to open a drugstore after his graduation from the University of Michigan School of Pharmacy. A native of Jackson County, Cushman and his business partner James C. Reed operated Reed & Cushman in Three Rivers from 1869 to 1875, when Reed sold his interest to Cushman, who operated the business on his own until 1884.

Henry DePuy Cushman had another idea. Seizing on an opportunity to sell his own products to county residents, he concocted remedies, but he quickly and quietly discontinued ineffective medications returned by dissatisfied customers. He persisted for several years, and in 1886, Mr. Cushman developed a concoction that was both cheap to manufacture and easy to sell to sufferers of hay fever, bronchitis, the common cold, headaches, neuralgia, catarrh and diseases of the head.

(No Model.)

H. D. CUSHMAN.
INHALER.

No. 476,132.

Patented May 31, 1892.

Henry Depuy Cushman, a Three Rivers pharmacist, invented the menthol inhaler using locally grown mint as an integral ingredient. *Courtesy of the United States Patent Office.*

Using mint, the main ingredient in menthol, readily available from growers in St. Joseph County, he introduced the Cushman Menthol Inhaler.

Physicians around the world recommended Cushman's Menthol Inhaler, including Dr. J. Lennox Browne of the Central London Throat and Ear Hospital and author of *Diseases of the Throat and Nose*, who wrote in a medical textbook:

> *For all forms of disease causing obstruction to the natural breathway, I prescribe Cushman's Menthol Inhaler to the extent of hundreds per annum. Inhaled Menthol checks in a manner hardly less than marvelous, acute Colds in the Head; it arrests sneezing and rhinal (nasal) flow; it relieves and indeed dissipates Pain and Fullness of the Head. By its use, when the nasal discharge is excessive, it is checked; when deficient, thickened and malodorous [foul smelling] as in Chronic Catarrh, its healthy character is restores, fluidity promoted and the foul smell corrected.*

The financial success of Cushman's Menthol Inhaler and Cushman's Menthol Suppositories, which included among its ingredients morphine and cocaine, released Mr. Cushman from day-to-day operations and allowed him to devote his leisure time to the Three Rivers community, where he served four terms as an alderman and as a member of the water board for seven years.

WHO IS BURIED IN CHIEF SAUGANASH'S GRAVE?

Events in the life of Chief Sauganash reflect his dual heritage as the son of a British military officer and a Mohawk mother. Known both as Chief Sauganash and Billy Caldwell, he served as interpreter for Tecumseh, who led a confederation of tribes. Chief Sauganash negotiated treaties between Native Americans and the U.S. government, yet in the 1830s, one of these treaties led to the displacement of St. Joseph County's Potawatomi tribe.

Duality and mythology followed the chief throughout his life and ultimately to his grave. Reports of his death in Three Rivers, as published in the *Grand Rapids Herald*, gave the following account:

> *Jumping into the saddle, he rode along to a point in the woods on the Sac War trail overlooking the Prairie River. And there, under the trees, he was shot to death.*

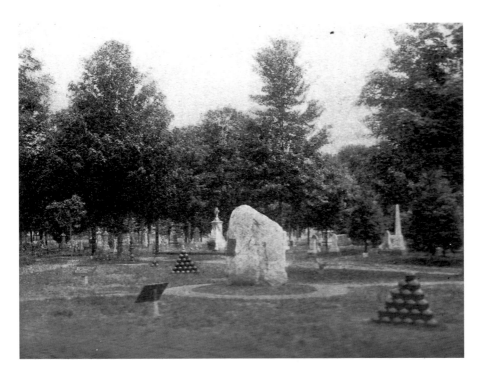

Riverside Cemetery in Three Rivers is the final resting place of Chief Sauganash. Or is it? *Courtesy of the St. Joseph County Historical Society.*

The executioners placed him in a sitting posture, in a pen, on the ground. The white settlers here learned the circumstances of his death and later gave the body a decent burial. The spot was marked at the time, with stones placed near the tree. And these served as a guide for the permanent marker placed by the D.A.R.

The location of the DAR marker is in Three Rivers' Riverside Cemetery. But was Chief Sauganash killed and buried in Three Rivers?

The people of Council Bluffs, Iowa, would disagree. An organization dedicated to preserving the history of that city claims, "Billy Caldwell died of cholera in 1841 and was buried in the cemetery behind the mission."

So his duality continues. Chief Sauganash died and was buried in Three Rivers, Michigan, and Bill Caldwell died and was buried in Council Bluffs, Iowa.

POTATO PLANTER

As president of Oxford College, a women's college in Ohio, Reverend Faye Walker kept a busy schedule—attending rallies for United States president Benjamin Harrison, whose wife, Caroline Scott, attended Oxford College; organizing European travel for the school's 175

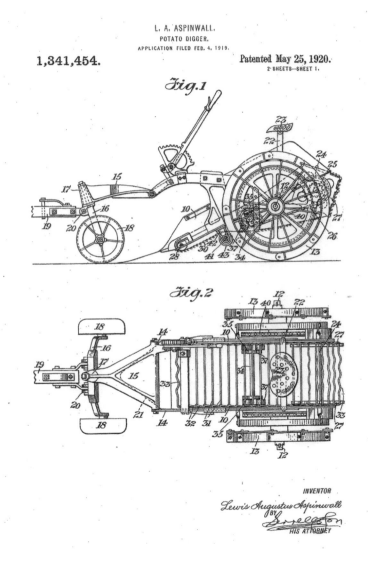

Lewis Augustus Aspinwall received a patent from the United States Patent Office for his potato planter. *Courtesy of the United States Patent Office.*

students; and advocating for the creation of a national university in Washington, D.C.

It seems odd that Mr. Walker would have time to write a testimonial for, of all things, a potato planter, but he had something to say about the quality of equipment he purchased, so he sent a letter to the manufacturer in Three Rivers:

> *Gentlemen: I desire to say that the Aspinwall Potato Planter which I bought of you last spring has given us perfect satisfaction. I do not think it is possible to make an implement that would do the work so thoroughly, easily and rapidly as this one. The increased amount of production, the saving of labor and the rapidity of planting, as well as the facility for fertilizing, all speak volumes in praise of the Aspinwall Planter. Sincerely yours, Faye Walker President of Oxford College. October 31, 1890.*

Faye Walker was not the only happy potato planter to praise the Aspinwall Potato Planter. A farmer from Tioga, Pennsylvania, called it "a daisy from Daisyville." A resident of New York State proclaimed it "a perfect machine."

But what was so special about Lewis Augustus Aspinwall's potato planter? For centuries, potatoes had to be planted by hand—slow, backbreaking work—but Aspinwall's machine automated the process. With a team of horses, a farmer could plant and fertilize rows and rows, all while riding atop the potato planter.

Mr. Aspinwall spent nearly $20,000 traveling through Europe, studying potatoes and perfecting his machine before settling in Three Rivers in 1884. The Three Rivers factory, which employed thirty men, was "the only concern in the world making a complete line of potato machinery." Unfortunately for Mr. Aspinwall and Three Rivers, a fire destroyed the factory, and he moved the business to Jackson, Michigan.

Mr. Sheffield's Secret

George Sheffield commuted in darkness from his home to his job as a mechanic in Three Rivers; he didn't dare travel in daylight because he knew he what he was doing was against the law. He kept his secret from his co-workers at J. Willits & Sons as long as he could, until one cold, wintry night his secret was exposed.

Mr. Sheffield's little invention was the basis of a global industry located in Three Rivers. *Courtesy of the St. Joseph County Historical Society.*

As he traveled home along the railroad tracks that led east from Three Rivers, Mr. Sheffield noticed a broken rail, certain to cause on oncoming train to derail. He immediately took a lantern from a local farmhouse and flagged down the train before it hit the broken rail.

Of course, the Michigan Central Railroad workers were grateful to Mr. Sheffield for averting certain disaster, but the railroad executives had a dilemma when they discovered he had been riding a homemade vehicle along their railroad tracks without their permission.

To save time and energy, George Sheffield had created a machine: the "velocipede," which resembled a bicycle with three wheels—two on one rail and a third on the opposite rail—propelled by a push-pull combination of hands and feet that glided along the tracks quicker than he could travel by foot. But he was trespassing on railroad property and could have caused an accident.

As interest in his invention spread, a railroad executive commissioned Mr. Sheffield to build velocipedes for track inspectors.

In 1879, Mr. Sheffield secured a patent for his invention and began a global manufacturing company in Three Rivers.

White Pigeon Township

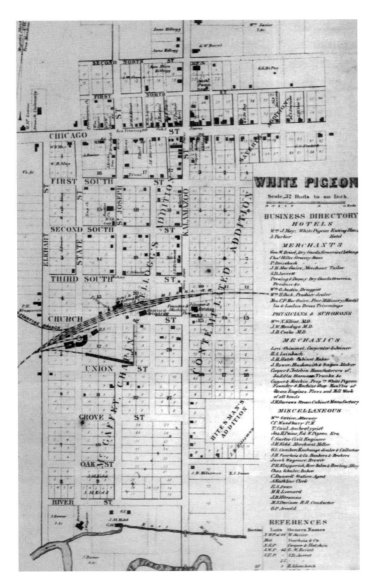

Map of White Pigeon. *Courtesy of the St. Joseph County Historical Society.*

BOTANIC PHYSICIAN

Dr. Amariah Bennett introduced St. Joseph County to the principles of medicine developed by Samuel Thomson, a New Hampshire farmer who treated illness with herbal remedies. Resented by traditional physicians, the techniques of Thomsonian and his botanic physicians gained popularity among patients who lived in rural areas abundant in the raw materials used to make drugs.

Determined to increase awareness of this alternative form of medicine, Dr. Bennett published in White Pigeon the *Vegetable Herald*, a medical journal that brought news of developments in the field. Little is known about the success of Dr. Amariah Bennett's medical practice in St. Joseph County, except that he successfully treated his own case of measles with herbs, but his remarks at a medical conference held in Schoolcraft show his steadfast faith in the healing power of plants. When asked by traditional physicians what he would prescribe to a patient suffering from corns, he said:

> *I would give the patient, first, a dose of lobelia, and repeat it at the end of an hour. At the end of the second hour, I would give him lobelia; and at the end of the third hour, I would administer a very large dose of lobelia, when doubtless, the corns would be cast off.*

Lobelia, also known as pokeweed, vomitwort and gagroot, brought Dr. Thomson unwanted notoriety when he was sued and later acquitted for causing the death of a patient he treated with the herb.

I'M DYING TO GO TO WHITE PIGEON

The first pioneers who settled in St. Joseph County during the late 1820s suffered long and arduous journeys fraught with danger, disease and other hardships, yet they persevered, following their dreams to a new land where they met with more hardships.

Although he and his family didn't reside in St. Joseph County for very long, Bennington, Vermont native Leonard Cutler's remarkable determination to reach St. Joseph County—and, in particular, White Pigeon—shows the kind of spirit typical among the county's earliest settlers.

With their father nearly delirious from a fever of unknown origin, Leonard Cutler's sons decided to go no farther on their journey to White Pigeon, stopping the family wagon along the trail to discuss the seriousness of their father's condition. They finally carried him out of the wagon and made a comfortable bed for him to die in.

A history of St. Joseph County written in 1877 recollects the situation:

> *As soon as the sons could command their feelings sufficiently to ask the question, they inquired what they should do with him in the event of his death, where they should bury him? He replied, "Not here, but on White Pigeon Prairie; there is where I started to go, and there I am going, dead or alive. If I die, put me in the wagon and take me to that prairie and there bury me. But I'm not going to die now,"—and die he did not. The family drove to White Pigeon Prairie which they selected for their new home, and Mr. Cutler was soon himself again.*

Leonard Cutler, along with his sons and neighbors, built a primitive house and planted a nursery from which "a great many of the first orchards in the county were supplied." Though far from luxurious, the structure served the family well. They boarded other newly arrived pioneers in their home. In June 1829, Samuel Pratt boarded with the family; "a part of the consideration for his accommodation was that he should assist in grinding half a bushel of shelled corn in Heald's mill every other day." They even played host to Governor Cass, who "accepted the luxury of a bed" on his way to Chicago.

THE HARNESS MAKER AND THE SOLDIERS

In September 1861, harness maker Harold J. Bartlett said goodbye to his wife and young sons and began his journey to White Pigeon, a distance of nearly 180 miles. He traveled by coach and train because his country needed him. A newly formed unit of Michigan soldiers needed this experienced craftsman to make and repair harnesses for its horses, for which he was paid a salary of thirty-four dollars per month.

While at Camp Tilden, located near the railroad depot, he worked in a civilian shop, where he spent most of his free time, including nights he preferred not to return to camp.

Letters to his wife are those of a happy man who expects to return home soon. On October 15, 1861, he wrote:

> *Tell Gene* [his young son] *that I have got him a pretty little poodle dog & half a bushel wall nuts* [sic] *for him. If I come home before we leave here I shall bring them.... This afternoon I have been making collars in a harness shop here, and if we stay here, I shall make quite a little in the shop.... There is a nice lot of soldiers here. About twelve hundred. It takes four hundred and seventy-four pounds of beef for one meal.... I tell you I have got a splendid dog for Gene.*

Bartlett continued to ply his trade on the side while his fellow soldiers trained for battle, often marching around the White Pigeon train depot wearing their civilian clothes (uniforms did not arrive until December), carrying sticks instead of guns because none were furnished.

He writes to Rose again in December, pronouncing the uniforms "very pretty indeed" and telling her that a neighbor from Clarkston smashed his foot "a fooling with the turn table on the railroad."

The unit departed White Pigeon on December 9, 1861, and despite what might be considered a relaxed atmosphere that allowed enough free time to freelance on the side, Bartlett served his country for three years without ever seeing his family.

If you visit Depot Park, you will see a monument to these men and the ground on which they trained.

THE UNIVERSITY OF MICHIGAN

The University of Michigan was a noble venture in White Pigeon that former Constantine resident Governor Barry declared was "destined to be of the greatest importance to the people of the state" and theologian Burke Aaron Hinsdale of Ann Arbor said was "cut off not a moment too soon." Perhaps both men were correct.

Almost immediately after establishing the University of Michigan at Ann Arbor, the Board of Regents faced a multifaceted dilemma. In his book, *A Memoir Embracing an Epitome of the Transactions of the Regents of the University with some Reasons for the Adoption of their Important Measures*, Zina Pitcher wrote:

Having selected the site of the University, secured the means of erecting the buildings, purchasing the library, and of doing other things necessary to lay its foundation, it became apparent that the materials for the construction of the living edifice were not at hand. The blocks for the statuary were in the quarry, but there were no hands to hew them into form.

The University of Michigan was low on funds, and Michigan's poorly educated students didn't qualify for admission: "The common schools were then in chaos, and our whole system of Public Instruction in the State, at best, of inchoation."

The Board of Regents hoped to solve both problems with the establishment of branches around the state. Tuition collected from students attending branches would go directly to Ann Arbor to get the stones out of the quarry. College prep courses at the branches would whip students' brains in shape for the rigors of the university.

The Board of Regents sent a special agent around the state to find towns whose citizens wanted a branch (many towns applied—just think of the prestige!) and were willing to pay for a school building (that narrowed the field considerably). In 1838, eight branches opened, one in White Pigeon. The folks in White Pigeon not only donated a fine building, but they also allowed women to attend classes.

In 1842, the White Pigeon branch hired a new principal: Jonathan Edwards Chaplin, a man with an impressive resume. He served as aide-de-camp to General Porter in the War of 1812. Armed with a law degree, he hung up his shingle in Urbana, Ohio, and after completing studies in religion, he was appointed principal of the Norwalk Seminary before departing for White Pigeon.

In his book *Protestantism in Michigan: Being a Special History of the Methodist Episcopal Church*, Elijah Holmes Pilcher recalls that Reverend Chaplin was

appointed Principal of the branch of the University located at White Pigeon, a post which he held until death put a period to all his labors. In this truly responsible position, such was his catholic spirit, such the judicious management of this school, that while he was beloved by his pupils, he acquired the confidence of the entire community in which he lived, and gave satisfaction to all parties.

All was well in White Pigeon, but the scheme to rescue the University of Michigan at Ann Arbor with branches didn't succeed. Instead of generating money, the branches operated at a loss, and in 1846, they were closed.

Selected Bibliography

Aggelis, Steven L. *Conversations with Ray Bradbury.* Jackson: University of Mississippi Press, 2004.

Asians and Pacific Islanders in the Civil War. Washington, D.C.: National Park Service, 2015.

Colon Express. "The Opera House That Colon Forgot." July 13, 1950.

Cooper, Richard W. *Michigan Reports: Cases Decided in the Supreme Court of Michigan from March 30 to June 5, 1922.* Chicago: Callaghan & Company, 1922.

Cutler, H.G. *History of St. Joseph County Michigan.* Vols. 1 & 2. Chicago: Lewis Publishing Company, 1911.

Eichler, Victor B. *Emily Joy & the Woman Who Trained Horses: A Glimpse into the Fascinating Life of Madame Marantette of Mendon, Michigan.* Three Rivers, MI: Shantimira Press, 2005.

1827–1877 History of St. Joseph County, Michigan, with Illustrations Descriptive of Its Scenery, Palatial Residence, Public Buildings, Fine Blocks, and Important Manufactories. Philadelphia: L.H. Everts Co., 1877.

Estes, Frances L. *Mendon Before the Fire 1916.* Lansing: Michigan History Division, Michigan Department of State, 1978.

Genco, James Gordon, Harold James Bartlett. *To the Sound of Musketry and Tap of the Drum: A History of Michigan's Battery through the Letters of Artificer Harold J. Bartlett, 1981–1864.* N.p.: R. Russell Books, 1983.

Hair, Robert E. *Klinger Lake: Its Origins and Growth.* Klinger Lake, MI: Klinger Lake Association, 2001.

———. *Sturgis, Michigan: 1930 to 1945.* Sturgis, MI: R.E. Hair, 1996.

Harland, Marion. *Breakfast Luncheon, and Tea.* New York: Charles Scribner's Sons, 1875.

"Independent Operator Foils Bank Robbery in Michigan." *Telephoney: The American Telephone Journal* 77 (1919).

Kellogg, R.M. *Kellogg's Great Crops of Strawberries and How to Grow Them the Kellogg Way.* Three Rivers, MI: R.M. Kellogg Company, 1920.

Kerrigan, William. *Johnny Appleseed and the American Orchard: A Cultural History.* Baltimore, MD: Johns Hopkins University Press, 2012.

Landing, James E. *American Essence: A History of the Peppermint and Spearmint Industry in the United States.* Kalamazoo, MI: Kalamazoo Public Museum, 1969.

Loughborough, John Norton. *The Great Second Advent Movement: Its Rise and Progress.* Washington, D.C.: Review and Herald Publishing, 1909.

"MasonicWiki of the Michigan Masonic Museum and Library." masonichistory.org.

Michigan Pioneer and Historical Society. *Historical Collections.* Lansing: Michigan State Historical Society, Michigan Historical Commission, various dates.

Michigan State Board of Health. *Annual Report.* Vol. 18. Lansing, MI: Robert Smith & Company, 1892.

Mires, Charlene. *Capital of the World: The Race to Host the United Nations*. New York: NYU Press, 2013.

Nation, Carry Amelia. *The Use and Need of the Life of Carry A. Nation*. Alpena Pass, AK, 1908.

Noorbergen, Rene. *Ellen G. White: Prophet of Destiny*. Brushton, NY: TEACH Services, 2001.

Peck, George W. *Joint Documents of the State of Michigan for the Year 1877*. Lansing: State of Michigan, 1877.

Portrait and Biographical Album of St. Joseph County, Michigan Together with Portraits and Biographies of All the Governors of the State and the Presidents of the United States. Chicago: Chapman Brothers, 1889.

Redfield, Isaac F. *A Practical Treatise Upon the Law of Railways*. Boston: Little, Brown and Company, 1858.

Riley, H.H. *Puddleford, and Its People*. N.p.: Samuel Hueston, 1854.

Romig, Walter. *Michigan Place Names: The History of the Founding and the Naming of More Than Five Thousand Past and Present Michigan Communities*. Detroit, MI: Wayne State University Press, 1986.

Silliman, Sue. *St. Joseph in Homespun: A Centennial Souvenir*. Three Rivers, MI: Three Rivers Publishing Company, 1931.

Snodgrass, Mary Ellen. *Encyclopedia of Kitchen History*. New York: Taylor & Francis, 2004.

United States Patent Office. www.uspto.gov.

Van Noord, Roger. *Assassination of a Michigan King: The Life of James Jesse Strang*. Ann Arbor: University of Michigan, 1988.

ABOUT THE AUTHOR

Kelly Pucci is a board member of the St. Joseph County Historical Society and a contributor to the *Sturgis Journal*. She specializes in deeply researched subjects from beekeeping, to true crime, to coming-of-age ceremonies in the South Pacific. This is Kelly's second book; *Camp Douglas: Chicago's Civil War Prison* (Images of America), published in 2007, was her first. She currently lives in Colon, Michigan, the "Magic Capital of the World."

Visit us at
www.historypress.net

···

This title is also available as an e-book